A1283

Margaret Pierpoint - borrowed JR. 16-1-86. 14.50

Margaret Pierpoint - borrowed JR. 16-1-86. 14.50

COUNTRY LANDSCAPES

IN WATERCOLOR 751.4

"Watercolor is such an expressive medium that once you have become familiar with the variety of effects you can create with it, you will possess a language with which to describe the beauty that you find in your favorite landscapes. In this case, the subjects are farmlands in mountains, woods, coastal regions, and moors. But these same techniques, once understood and mastered, can be applied to any subject, for that is the nature of art."

COUNTRY LANDSCAPES IN WATERCOLOR

BY JOHN BLOCKLEY

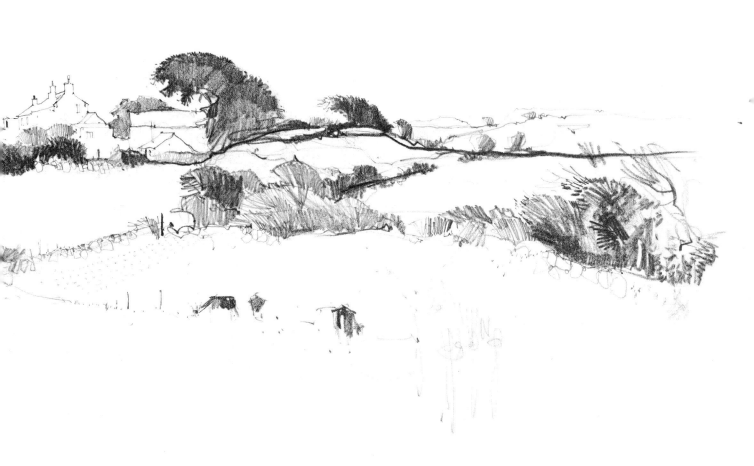

WATSON-GUPTILL PUBLICATIONS/NEW YORK

For Margaret, Pamela, and Ann

First published 1982 in New York by Watson-Guptill Publications,
a division of Billboard Publications, Inc.,
1515 Broadway, New York, N.Y. 10036

Library of Congress Cataloging in Publication Data
Blockley, John.
 Country landscapes in watercolor.
 Includes index.
 1. Water-color painting—Technique. 2. Landscape
painting—Technique I. Title.
ND2240.B6 1982 751.42'2436 82-8358
ISBN 0-8230-1616-1 AACR2

Manufactured in Japan

First Printing, 1982

1 2 3 4 5 6 7 8 9/86 85 84 83 82

Acknowledgments
My thanks to Margaret and Moira for their support and practical help. To Michael Petts for the faithful photographs. To Lydia Chen for her perceptive editing. To Bonnie Silverstein for her insight and flair and for giving the book a working structure. And, of course, to David Lewis, who started it all over breakfast one morning and who has steered the book through all its stages.

CONTENTS

"... *The wild catastrophe of the breaking mountains. ...*"
—Wordsworth

A REVIEW OF

The stages of my painting process alternate between two goals: to imply or interpret the nature of the landscape, and to explicitly describe its man-made features. My procedure is simple.

I paint mostly in the studio from drawings made on the spot. In my drawings, I concentrate on recording factual information. Then, in the isolation of the studio, I develop my own interpretations of the scene. Particular characteristics of the terrain can be recalled with the aid of a few notes marked on the drawings—words like "bronze grass," "stippled," and "mottled." But while such notes are sufficient to register the particular characteristics of a landscape, I find that details and proportions of buildings must be drawn with accuracy—not left to the memory or imagination.

I therefore try to keep these two functions—drawing and painting—separate. I think of painting as explorative and experimental and therefore I think of drawing as fact-finding, so in my drawings, I concentrate mainly on the buildings and ignore the landscape to a large extent while I emphasize the more abstract and textural qualities of the landscape in my paintings. In other words, on the scene I look for the abstract qualities the landscape evokes, but describe it by drawing it in literal terms. Then, in the studio, I translate my impressions of the scene into a painting through an expressionistic treatment. In fact, in looking at my paintings, I almost always seem to place the main activity and excitement *away* from the central buildings and seem more interested in painting the parts of the scene I haven't drawn in great detail. But whether I'm painting the center of interest or the surrounding textures, I enjoy it all—the looking, the dreaming, the note-taking and drawing, and then the creative action in the studio.

Spontaneous drawings can also be made as a quick response to something that catches your eye. Though they take only a minute or two to do, such drawings should not be undisciplined or drawn carelessly. I intensify the impulsive quality of these drawings by grabbing my sketchbook at such moments of inspiration and drawing quickly on whatever page I happen to open to. Thus empty pages are scattered throughout my sketchbooks, some sketches are upside down or overlap other sketches. However, despite the impulsiveness of the process, I still regard these drawings as part of the fact-finding process, not free interpretations.

In terms of painting, I can only partially agree with the attitude that watercolor is a "first-time, never-touch-it-again" medium. In *Capturing Nature in Watercolor* (Watson-Guptill, 1980), author Philip Jamison expresses my attitude toward watercolor perfectly. He says, "I do not believe in the old adage that a watercolor must not be worked over. It simply should not look overworked."

TECHNIQUES

So I am hooked on the medium, with its fluidity and transparency, and I delight in the traditional process of working wet-into-wet. But I have also found that in order to paint the terrain as I see it—blotched, mottled, grainy—I must experiment. So I stipple paint onto the dry paper with a sharpened stick or draw lines with a stick (or pen) dipped in watercolor. I apply paint with crinkled paper. I blot color with a rag, the sleeve of my jersey, or my thumb (thumbprints create an excellent texture). I scratch, scrape, and wash away partially dried paint under the tap. And I stand a few paces from the painting and, with a quick movement of my wrist, flick paint from a large brush into the wet painting surface. I also place short nervous brushstrokes beside aggressive paint dripples, run rivulets of water through drying paint, and drip waterproof black ink into watercolor washes. Then I dry parts of the ink with a hairdryer and hose away still-wet parts to produce patterns of light and dark. Processes such as these suggest, for me, the surface of the landscape.

These processes are exciting because they are never quite predictable; they always retain an element of surprise. Against these abstract, emotional expressions, I introduce accents of drawing, small predictable pen flicks to indicate grass or stones, and—away from the area of experimentation—I draw farm buildings and their neighboring features, such as trees, fences, and stone walls. In other words, I try to balance areas of interpretation with statements of fact.

Thus, the aim of my paintings is to imply the nature of the landscape, while explicitly describing the man-made features. And the interest for me is in integrating these opposing treatments into a single painting. I regard the accurately drawn buildings as a link between interpretive painting and reality, and this guiding philosophy helps me when I am faced with a new piece of white paper in the studio.

Each morning, I walk into the studio—an enclosed area isolated from the landscape—and revive the motivation for painting each new scene from my sketchbook facts and memories. I may not recall the mood of a particular moment, but the collective experiences based on years of observation, coupled with the drawings I've made, are enough to give me an idea of what I want to say before I put paint to paper. Then, once I establish the mood and basic motivating idea, I plan the arrangement of the painting—where to place the farm buildings and how to order the general pattern of light and dark. This is all the planning I require—the rest of the painting is developed as I work. As I paint, one brushstroke prompts another, patterns and textures evolve, and accidents occur that can be exploited—but I always keep in mind the initial idea that prompted the painting.

In this section, I demonstrate how I paint a number of farm landscapes. They are all based on traditional wet-into-wet watercolor painting, but I also apply nontraditional techniques to express my interest in the texture of the landscape. I look for hard and soft edges, too, and this analysis of edge values is the key to my way of seeing and painting.

My small watercolor cloud sketch shows traditional wet-into-wet painting. I brushed color over dry paper and worked darker color into it to give the atmospheric cloud effect. Because I was working on dry paper, the edges of the cloud are ragged and hard. I softened the edge slightly in places by blotting it with a damp brush.

I made this doodle to illustrate other types of edges. I began exactly as in the cloud sketch, with a wash of color on dry paper and worked darker color into it. Then I blotted patches of color within the wash with a damp brush, blotting paper, and with my fingertip wrapped in cloth. By pressing really hard with my finger, I was able to blot the color almost back to white paper. These blotted light patches have a variety of edges, both hard and soft. Sometimes, for texture, I drip black India ink into a wash and in turn drip water into the ink. Then I dry the ink parts unevenly with a hair dryer and wash away the still-wet ink under the tap. This gives a mottled, blotched pattern of black ink. Although you might find yourself reading things in it, this doodle is not supposed to represent anything. If you do, then you help me make my next point—that in my paintings I hope to hint and suggest rather than to explain everything. It is all a question of balancing one shape against another and of using a variety of edges to describe or suggest feeling, objects, textures—all the time building up to a single, positive statement.

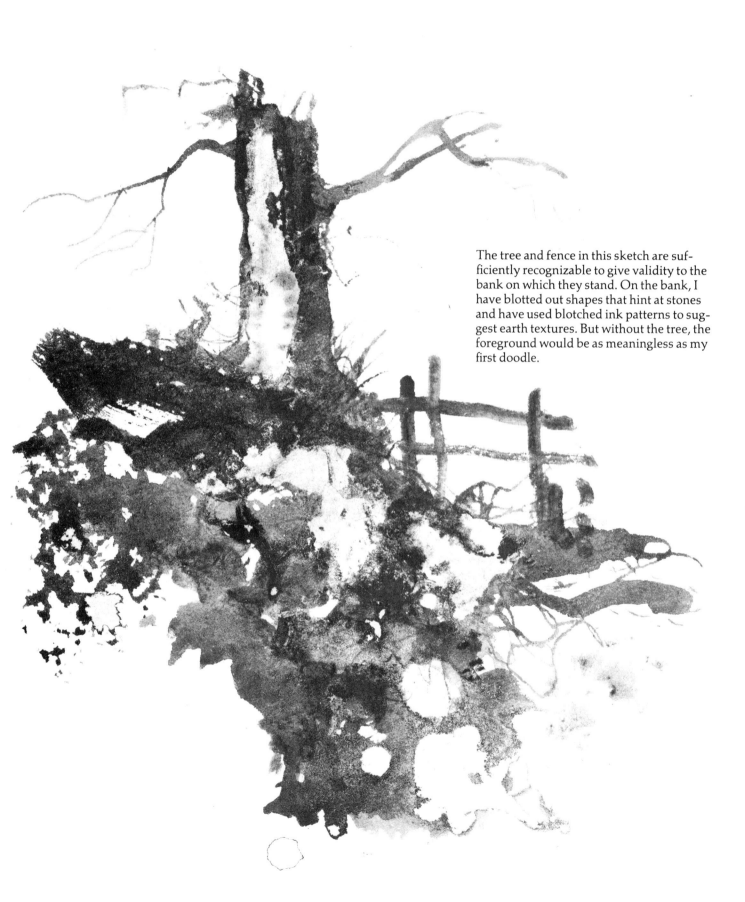

The tree and fence in this sketch are sufficiently recognizable to give validity to the bank on which they stand. On the bank, I have blotted out shapes that hint at stones and have used blotched ink patterns to suggest earth textures. But without the tree, the foreground would be as meaningless as my first doodle.

This sketch shows more clearly the edge variations that can be obtained by blotting. There is also a hint of thumbprint texture at the bottom—remember, anything is acceptable to suggest a texture!

Although this is just another doodle, it does go a step further. I obtained the hard-edged white buildings by covering them with masking fluid (sold under brand names like Maskit in the United States). The rest of the painting is wet-into-wet painting with a few hard-edged descriptive bits. I drew some lines with a stick dipped in watercolor when the painting was still damp—and again when it was dry. I deliberately kept such linear descriptions to a minimum, but they should be sufficient to give some meaning and substance to the whole.

The step-by-step demonstrations in color that follow incorporate the processes and thinking I have just illustrated.

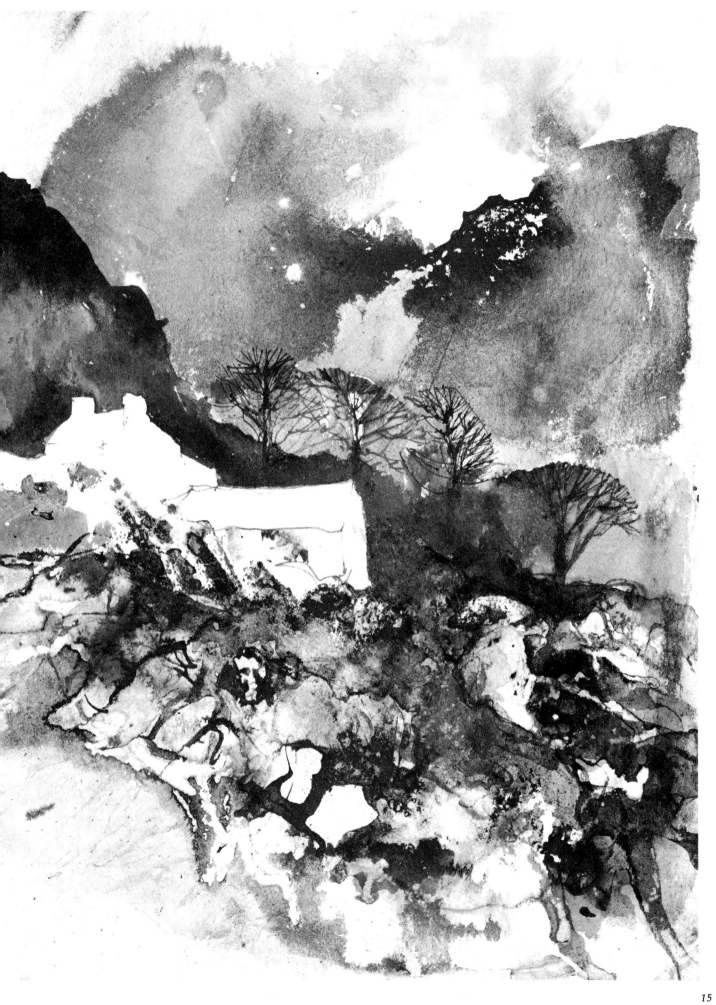

Painting hard, cool light and low-key colors

A MOUNTAIN SCENE

These stone barns rested on the lower slopes of the mountain and surrounded a small meadow. The meadow, with its pale grass, seemed like a breath of clear space between two broad planes of gray rock. The barns were simple and eloquent, belonging to the mountain yet relieving the heaviness of the rock color. The hard, cool light emphasized the bareness of the landscape and made the scene look slightly forlorn. Since the barns were some distance from the farmhouse, and were used only to store hay and shelter cattle in the winter months, the area did seem to be quiet and remote.

I deliberately ignored the principle of a dark foreground and a light mountain in the distance and instead kept both foreground and mountain dark. This created a sandwich effect that concentrated interest on the lighter passage across the middle of the painting. I also kept the hardest edges and the most precise drawing in this central band. Notice, also, the S-shaped composition that slowly directs the eye through the painting.

In organizing a composition, I often collect the principal features of a landscape into a single shape, then surround this shape with a wash of color. This immediately defines the center of interest while at the same time establishing the feel of the surrounding environment. It is also a quick way of overcoming the apprehensive start that we all dread. Here, I saw the buildings and the neighboring field as a single light shape enclosed by a darker tone. I decided to develop the ''enclosing'' wash with soft-edged forms and then to delineate the actual features of the farm buildings. These soft-edged forms provide a secondary interest, with the main interest concentrated on the farm.

I worked here, as in most of the paintings in the book, on unstretched 140-lb cold-pressed paper because, although it curls, it is sufficiently robust for me to work on and its surface has just the right balance of texture to hold color and at the same time accept smooth drawing. If it curls badly, and the painting is worth preserving, I stretch it after it dries. Soaking the paper at this point is all right as long as the paint surface isn't rubbed.

STAGE ONE

Since I want to be able to paint the gray surfaces of the mountainside freely, I first paint masking fluid over the shapes of the buildings to keep them clean. Then, with downward sweeps that capture the energy I feel in the sheer rock wall of the background, I apply a wash of very dilute burnt umber with hints of raw sienna and cobalt blue. I suggest the foreground slope with vertical strokes and paint the sky on the upper right in a circular pattern. After the first damp wash, I use a mixture of burnt umber and cobalt blue to brush soft darks into the wash to indicate the upward climb of the foreground and background slope.

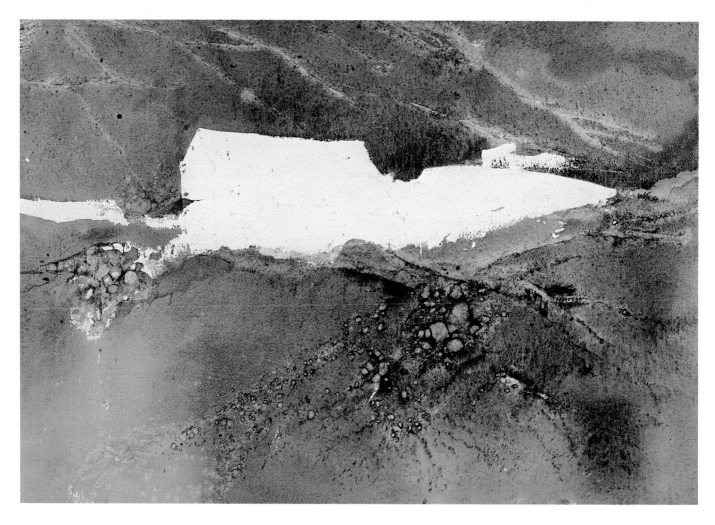

STAGE TWO

In the next layer of color, I intensify and extend the soft darks, working all the while into the still-damp wash. The colors melt into each other to form a consistent, gentle surface—the texture of stone smoothed by erosion. I lightly press blotting paper onto some areas in the middle background and foreground to suggest the graininess of the rock surface. Then I gently blot out the light-colored boulders in the foreground, wrapping a rag around my fingertip for the larger spots and around the end of a brush handle for the smaller dots. To accentuate the stones, I outline them with a pen dipped into watercolor, working while the paper is moist so that the lines remain soft. I also draw in a few patches of grass.

In the background, I use a stick to lift the still-damp color, leaving diagonal streaks on the mountains that repeat the rhythm of the barn roofs while, at the same time, representing the patterns I see behind the barn. The rocks in the foreground lead the eye to the barn, my center of interest. To give the composition the power I feel in the mountain slope, I have reinforced several diagonal movements: notice the V shape, open on the left-hand side of the picture and moving to a point on the right.

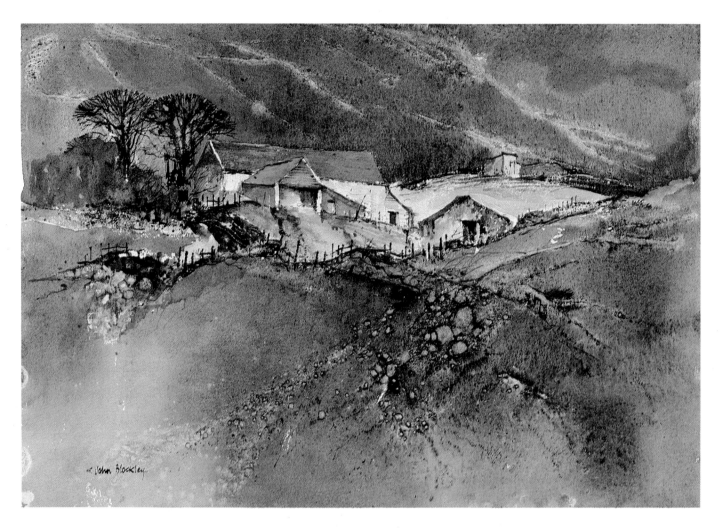

MOUNTAIN BARNS, WALES, *14" x 16" (350 x 410 mm)*

I peel off the masking fluid from the buildings with my finger and finish the scene, harmonizing the painting by using the same colors in these areas that I had used earlier in the mountains, burnt umber and cobalt blue. I also add yellow ochre and a little aureolin, plus some very diluted cadmium red for the grass and barns. I define the details of the buildings, fence, and trees with a pen dipped in watercolor—not ink. (I rarely draw with ink, because black is too strong and dark for the rest of the painting, and colored inks fade. The watercolor I use is made from what I call "yesterday's paint"—old, dried color mixtures from the mixing lid of the palette. I pick it up with a brush and a little water and transfer it to a steel-nibbed dip pen (the kind that doesn't have a reservoir). I don't feel this contradicts my use of ink in the larger, patterned areas; I simply find that a fine ink line contrasts too strongly against the watercolor and feel that I can draw a more subtle line with watercolor.

Expressing a soft, winter light

A WOODLAND FARM

In the winter the woodland takes on a mellow look, exposing to plain view the dormant vegetation and ancient tones of the earth. Under the soft, warm light, clustered farmhouses blend into each other and the warm, gray tones of the distant trees melt into the low-hung clouds of the sky.

In this painting, I wanted to show the soft winter lighting and warm gray trees, enlivened by the light-colored buildings. As in the preceding demonstration, I collected the buildings into a single shape, enclosed by foreground and background washes. This time, however, the surrounding washes became trees and foreground vegetation (rather than mountains). Then I developed the enclosed shape (the buildings) to suggest separate buildings, while still preserving the feeling that these buildings were bathed in winter light. Again, the detail in this painting was kept mainly within the enclosing wash.

The long grasses at the edge of the fields dry to an ochre color during the winter months. I show these grasses in the immediate foreground, but I am careful not to make them as bright as the buildings. In this way the eye is led by their lines and color to the buildings beyond, and the color is echoed in the distant sky to suggest the wintry warmth of the scene. The vertical thrust of the foreground weeds and the gentle fanning diagonals of the tilled earth draw the eye to the farmhouse on the left, where silhouetted figures and farming equipment are indicated.

STAGE ONE

I establish the position and outline of the buildings in pencil. Then I paint the sky with a thin, diluted wash of yellow ochre and cobalt blue. The yellow warms the sky and helps create the soft winter light I want to show. I cover the foreground with a fairly smooth wash of cadmium red, slightly grayed with a touch of yesterday's paint.

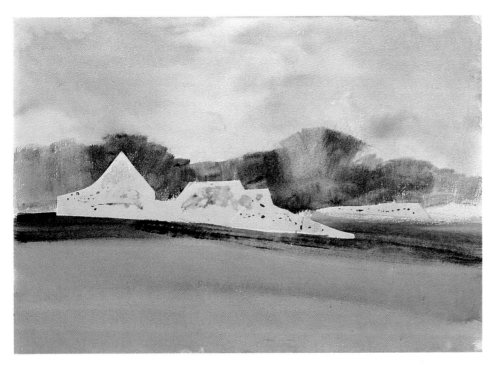

STAGE TWO

In previous demonstrations, I masked out areas with masking fluid. But this time, I use masking *film,* a plastic that comes in rolls, with a protective backing of paper that peels off and exposes the adhesive layer beneath it. Unlike masking fluid, which is brushed on with an old brush that must be quickly soaped out and cleaned of fluid before it dries, masking film is placed over the pencil outline and cut to the precise shape with a sharp knife and pressed onto the paper. It is sufficiently adhesive to stay in place while you paint but peels off easily when you're finished with it. I use it whenever I need really sharp edges, because it is considerably more precise than the brushed edge of the masking fluid.

I mask the buildings and distant field so I can work around them, keeping their edges hard in contrast to the softly blended distant woods. Then I paint the rounded treetops into the still-damp sky wash with downward strokes of burnt umber muted with Paynes gray, using a ½" (13 mm) sable brush. I also add dark, horizontal strokes of paint to the base of the farm.

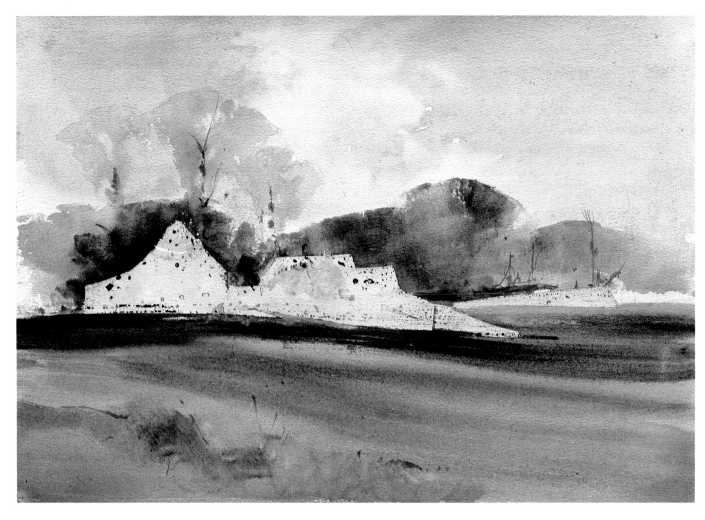

STAGE THREE

At this point I work fairly quickly. I sweep more layers of Paynes gray and burnt umber into the foreground, following the contours of the land. I also add a little aureolin yellow to the foreground while it is still damp to begin to establish the patch of dried grass. In contrast to my smooth treatment of the field, I build up the tones of the background trees against the buildings with darker washes of Paynes gray and burnt umber. Then, working while the paper is still damp so their shapes melt into the sky, I begin to form the tall trees on the left by dragging a round sable brush sideways over the almost dry paper.

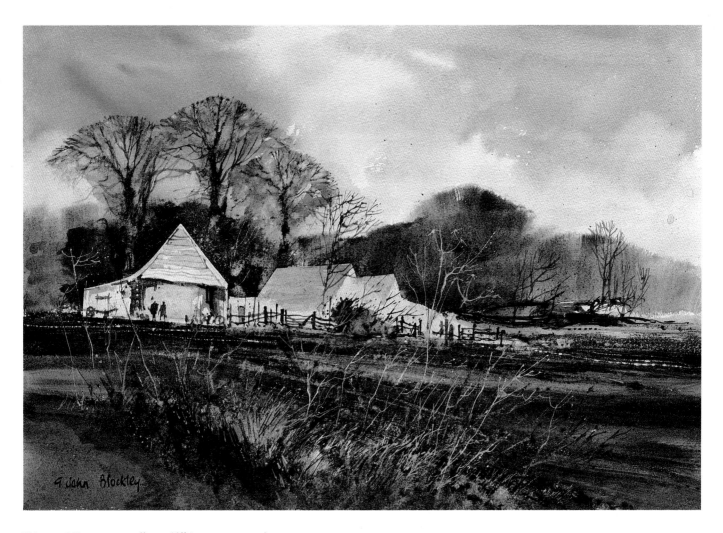

WINTER WOODLAND, 8″ x 11½″ (210 x 295 mm)

While the paper is still damp, I draw the trunks and delicate, spreading branches of the tall trees with a very fine brush. Next, I redampen the foreground, so that the final layer of colors blends in softly, and with long strokes I add deeper tones of burnt umber and Paynes gray. I allow the cadmium red underwash to show through and try not to paint the darks too heavily, since I want to create a mellow, not harsh, mood. When the paper is dry, I peel the masking film away and tint the buildings with a wash of yellow ochre. Then, I draw the foreground grasses with a pen and opaque white gouache lightly tinted with yellow ochre. And, with a pen dipped in watercolor, I draw the fence with freely waving lines. Finally, with a few dots and flicks of the pen, I suggest some activity around the farm. The sharpness of some of the twigs and grass blades contrasts with the softness of the land and trees and suggests the nippy air.

Working from dark to light

A RAINY DAY

I was attracted to this gray cottage looming out of the mist in the wet countryside and wanted to convey a sense of the changing weather. I also wanted to explore the contrasting textures—the hard edges of the house and stone wall that were gradually becoming distinct, and the soft, water-soaked ground and background forms still hidden in the mist. The heavy melancholy of the storm was still in the air, but the mood was slowly lifting as the weather cleared.

Rain-washed subjects call for special tonal judgments. At first sight, the cottages here appear as just a light mass against a clouded background, but the whole concept behind the painting is based on a sensitive analysis of tone and edge values. The overall bulk of the building is light, with variations of light within it. Flickers of light occur at roof edges, on chimneys, and on windows. I sometimes think that light is intensified along the corners and edges of building details. The painting is planned with just these few bright, light values in mind. To achieve this, the cottages are planned as a shade lighter than the sky, which has just a few intensely light passages. I saw the lines of bright light as sharp-edged and thus drew them with a knife edge dipped in masking fluid. I lowered the value of the light slightly elsewhere with broad color washes and kept the rest of the painting soft relative to the bright lights by working wet-into-wet and by blotting. Detail is generally subdued.

The processes behind the paintings are definable. I started with a critical assessment and recognition of an initial response to the subject and then calculated ways of expressing it. In this painting, the processes involved a critical value analysis, followed by decisions on the types of edges required and then on the means of best obtaining them.

STAGE ONE

I outline the cottage lightly with pencil. Since it is to be the center of interest, I carefully consider its size and position on the paper. The other elements in the scene are secondary, and will develop as the painting progresses, so I do not sketch them now. Once I have settled on the placement of the cottage, I retrace the outline with masking fluid and a round brush and fill in its shape. Now I am free to paint the background and foreground with wet washes without worrying about keeping the cottage area clean.

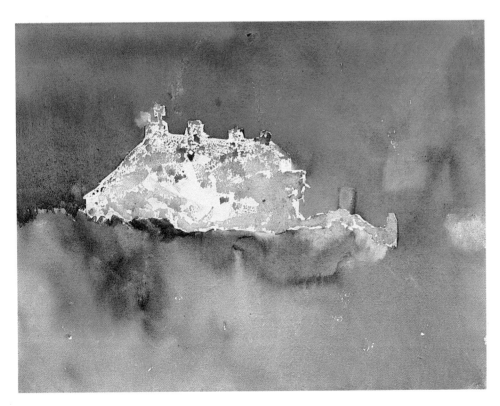

STAGE TWO

I brush color quickly over the paper, starting with the sky, using Paynes gray slightly modified with phthalo blue. As I carry this color to the bottom of the painting, I add raw sienna and a little burnt umber as a base for the wall and ground. The sky is deliberately made much darker than I eventually want it to be because of the blotting process I plan to use. (Note: I never wet the paper with water alone but always wash color over the paper to moisten it, then add more color to the wash—or I start with one color mixture on top of the paper and change the color as I progress downward, then work into it. I believe that if you're going to work wet-into-wet, you might as well work one wet color into another, instead of into just plain water.)

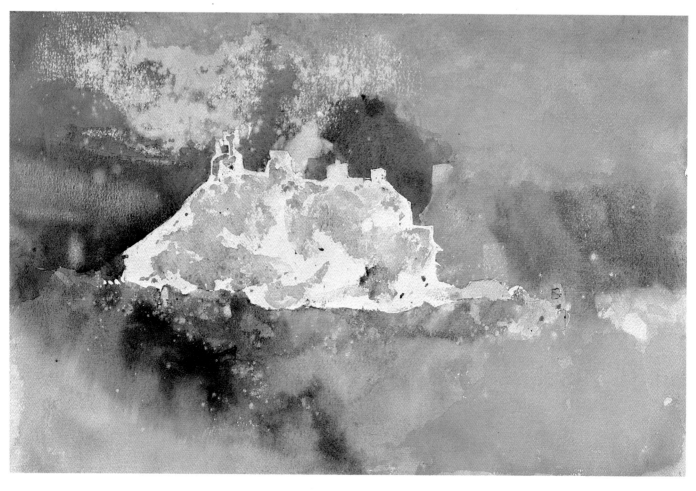

STAGE THREE

While the background wash is still wet, I immediately blot the sky area with a rag to lighten it, leaving darker areas where I will suggest secondary forms—such as a tree behind the chimneys and the barn to the left of the cottage. By pressing the rag unevenly in spots on the upper left, I suggest breaking clouds. By blotting the sky more gently and evenly on the right, I create another type of softness. As I block in the secondary elements, I begin to add more color. I lighten the blue of the background barn on the left, block out shapes of the buildings on the right, and add burnt sienna to the blue wash. Then I darken the blue where the tree will be and strengthen the left foreground with washes of phthalo blue, burnt sienna, and yellow ochre.

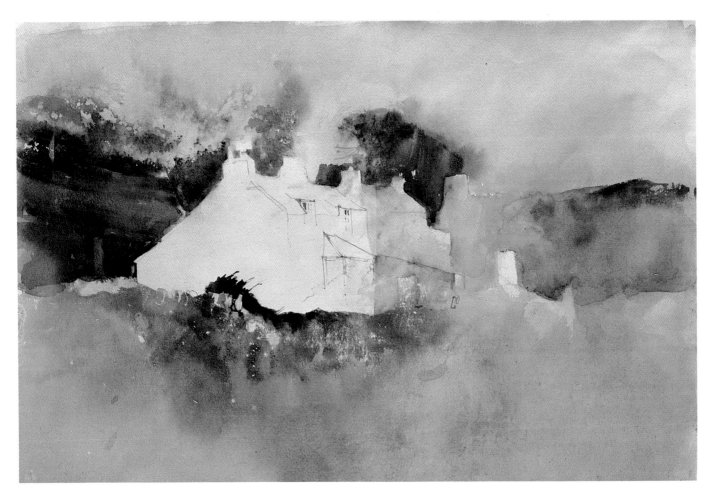

STAGE FOUR

When the paper is dry, I rub off the masking fluid with my finger, exposing the white shape of the cottage. Then I start to develop the painting, further describing the tree and barn on the left and beginning to draw detail in the cottage and foreground wall. I also tone down the color in the left foreground. Throughout the painting, I constantly adjust colors and tones by adding or lifting out. (Note: There is a difference in tone between Stages 3 and 4 because these stages were painted separately, and it is difficult to match a wash exactly.)

In this painting, I worked from dark to light by means of an unusual procedure in which light, soft forms were blotted out from a preliminary wash of dark color. Since the blotted forms emerge softly from the background, or seem to melt into it, this technique was perfect for producing the in-focus/out-of-focus character of the scene. For example, by blotting out the light part of the sky with a cotton rag, I got a very soft edge on the cloud. This speckled effect is very different from the one I would have obtained with a brush because of the cloth's uneven absorption of color. The subtractive process is unusual in that normally when one works from dark to light, the main dark is stated on the paper as a positive shape and then is surrounded by paler tones. But here, by starting with a dark wash and then lightening it to suggest secondary items, I don't actually paint a tree or a barn. Instead, I let these forms slowly emerge from the background wash. The softly blurred shapes also intensify the sensation of mist. The painting thus emerges through a continuous process of adding and subtracting wet color.

A word of advice about blotting out: You must act decisively, even though you can't see what you're doing under the rag. Timid blotting gives a worried look to the painting—so be bold. I've thrown out many paintings that have the wrong shape or edges, or other errors. But it's better to make mistakes than never to take a risk!

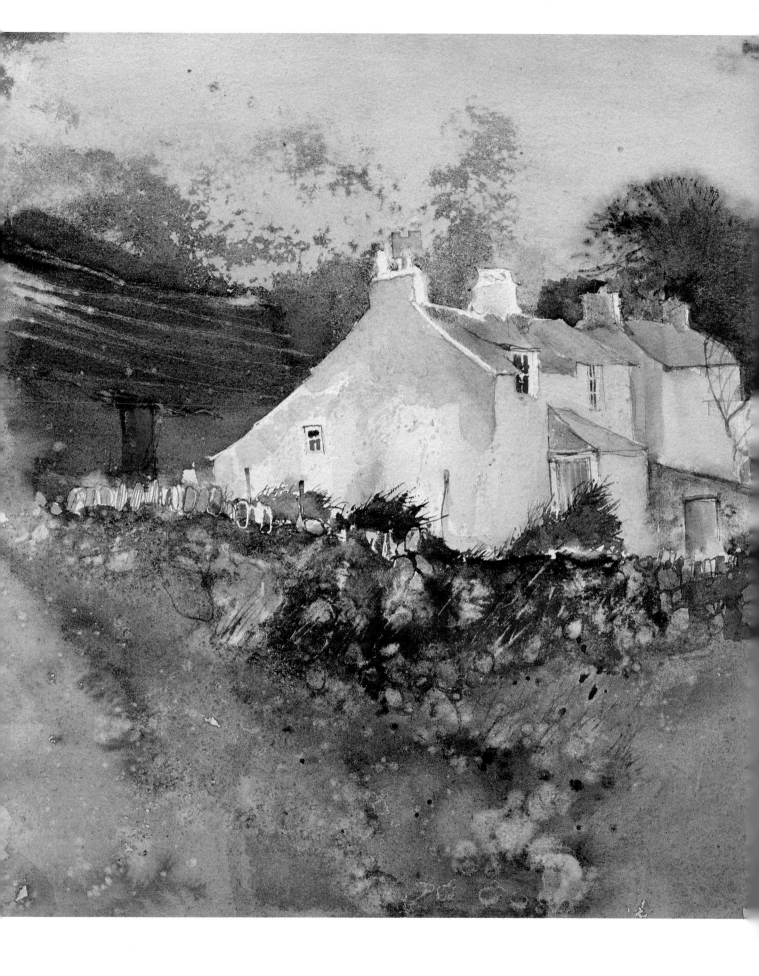

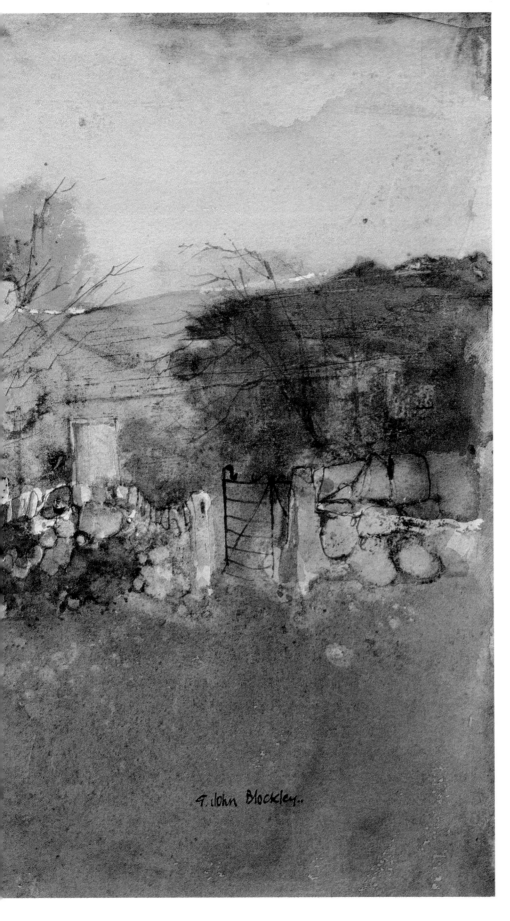

After the Rain, *12" x 16" (310 x 410 mm)*

I now fully develop the painting, adding details and more areas of color, creating different textures, and seeking an intriguing balance between the clarity of the cottage structure and the soft wetness of the natural environment. I add some tone to the cottage walls and hints of cadmium red to the chimney and doors. I place a few brushstrokes of color here and there to move the eye to different areas of the picture—the sky, the building on the right, the cottage details. With a stick dipped in paint, I draw tree branches in front of the cottage and on the right, as well as some twigs in the left foreground. Then I scratch a few lines on the barn roof with the end of my brush handle to give it a weathered appearance. Finally, I define the stones in the wall and the iron gate with a finely pointed brush.

Working from light to dark

MOUNTAIN COTTAGES

In this scene I was struck by the tension in the line of cottages, the two on the left linked to the one on the right by a simple, seemingly delicate, black gate. The road cut between the two banks where the homes stood and continued up the mountains beyond, providing a strong countermovement to the horizontal direction of the cottages. Although I might be criticized for breaking the ''rules'' by not letting tones pale into the distance, I find that a heavy, overbearing background like this one gives great drama to the painting and serves to highlight the areas of interest in the middle distance. Also, as you may recall from preceding demonstrations, I often use an identical dark tone in the background and foreground to deliberately emphasize a light central area.

To build up the deep foreground and background tones while preserving the clarity of the cool mountain light, I started with light washes and worked wet-into-wet with darker color. After the paper dried, I added the final colors to produce hard-edged areas. The use of light-to-dark and wet-into-wet techniques gives the scene its crispness.

Everywhere I go, I look for specific conditions to paint, then echo them elsewhere with the idea of inviting the eye to wander through the painting, pausing when the treatment changes, then recovering the trail when the treatment is picked up again. For example, I saw the farmhouse as a flat shape, so I treated the tree in front of it as a flat shape, too. The cool light turned the gray farmhouses to silver, and so I painted some of the rocks silver. But since the barn roof was a warm gold, I painted some of the broken rocks that color, too. I also repeated the fine grain of the large rock on the right elsewhere in some of the smaller, broken rocks.

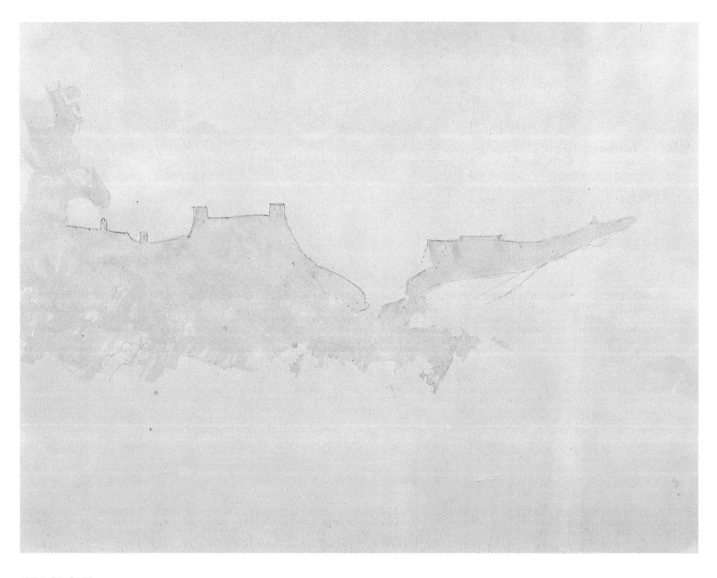

STAGE ONE

I think of the farm buildings and the rocks in front of them as a light passage between the dark foreground and the gray atmospheric distance beyond. To keep this area light, I mask it with masking fluid. As I brush it on, I make the rooftops hard-edged and precise, but I drag the masking fluid along the paper with a brush at the bottom to make a broken edge, so that the buildings will blend with the ground.

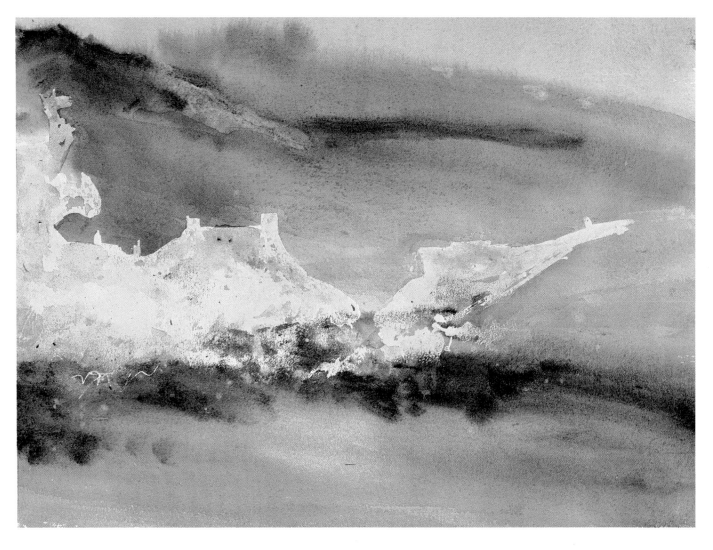

STAGE TWO
To establish the tones of the cool, hard mountain light, I brush a very thin wash of
Paynes gray over the entire paper. This is immediately followed by a stronger wash of
phthalo blue applied into the wet color above the buildings and a light cadmium red
wash applied to the ground below them. Cadmium red itself is a bright color, but as it
blends with the Paynes gray already on the paper, it becomes a subtle reddish brown.
Because the first wash is still wet, the edges of the strokes bleed and soften, and the
colors seem to dissolve into each other. Waiting until the paper is damp (not wet), I
add another layer of color: a few brushstrokes of burnt umber to strengthen the fore-
ground, and phthalo blue and Paynes gray to darken the upper edge of the mountain
on the left. The dark strokes on the mountain follow the general pattern of the build-
ings' rooflines—high on the left, falling toward the center, and then leveling off. By
repeating that movement, the shapes of the mountains serve to accentuate those of the
cottages.

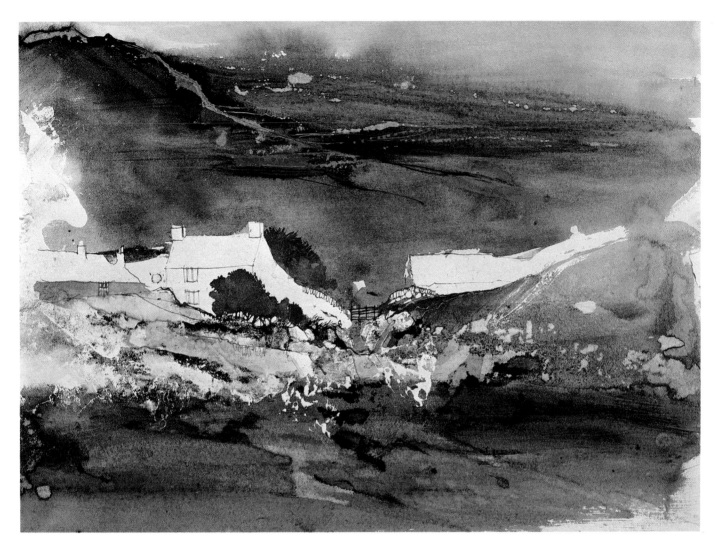

STAGE THREE

While the paper is slightly wet, I blot away color to suggest a road on the background mountain. I also blot out a few light patches near the foreground rocks. I blend more darks into the background to emphasize the road and to hint at side roads leading into it. In the foreground I add a few soft-edged, dark patches to suggest ground patterns. Although the road in the distance is a continuation of the road between the cottages, I find it more effective to let it disappear from view beyond the gate and then have it appear later as it climbs the hill. An unbroken line climbing vertically through the painting would visually deaden the horizontal motion of the composition and detract from that light central passage I want to emphasize. Good painting is always a matter of selection and discipline. When the paper is dry, I rub the masking fluid off the buildings and some of the rocks and begin to define the area of interest with a few pen lines and some brushwork. I also suggest some bushes beside the cottage on the left and darken the rock below the cottage on the right.

CWM PENNANT, NORTH WALES, *10″ x 15″ (255 x 380 mm)*

I model the rocks gradually by rubbing the masking fluid from a few rocks at a time and then coloring each piece of exposed paper in turn. This method permits me to build a jumbled pile of rocks rather than simply to produce a large shape. When the masking fluid is completely removed, I model the rocks with a small brush. Then I complete the buildings and draw the gate between them, tinting the buildings in lively colors that lead the eye from left to right. As a final touch, I add the distant mountain range and, in the foreground, just a hint of the road—if you don't look hard, you might not even find it!

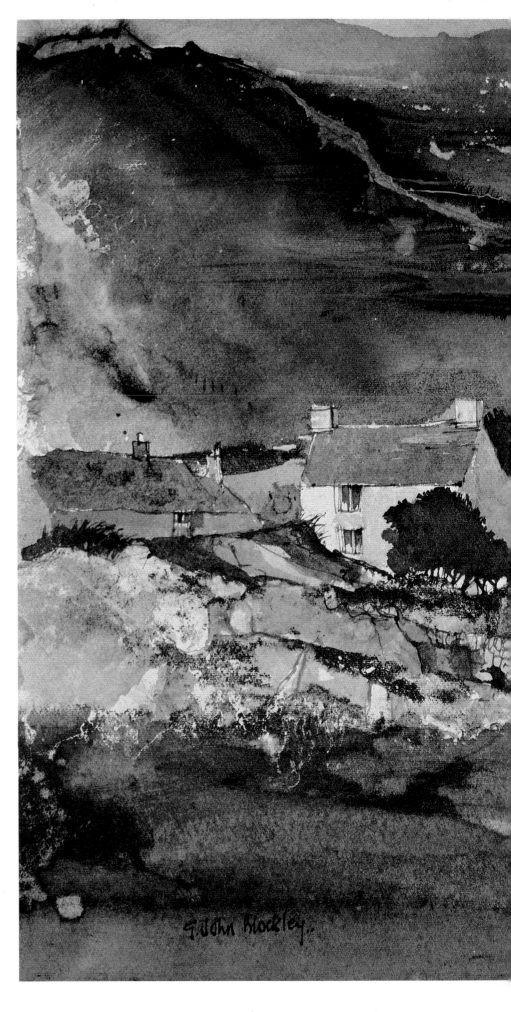

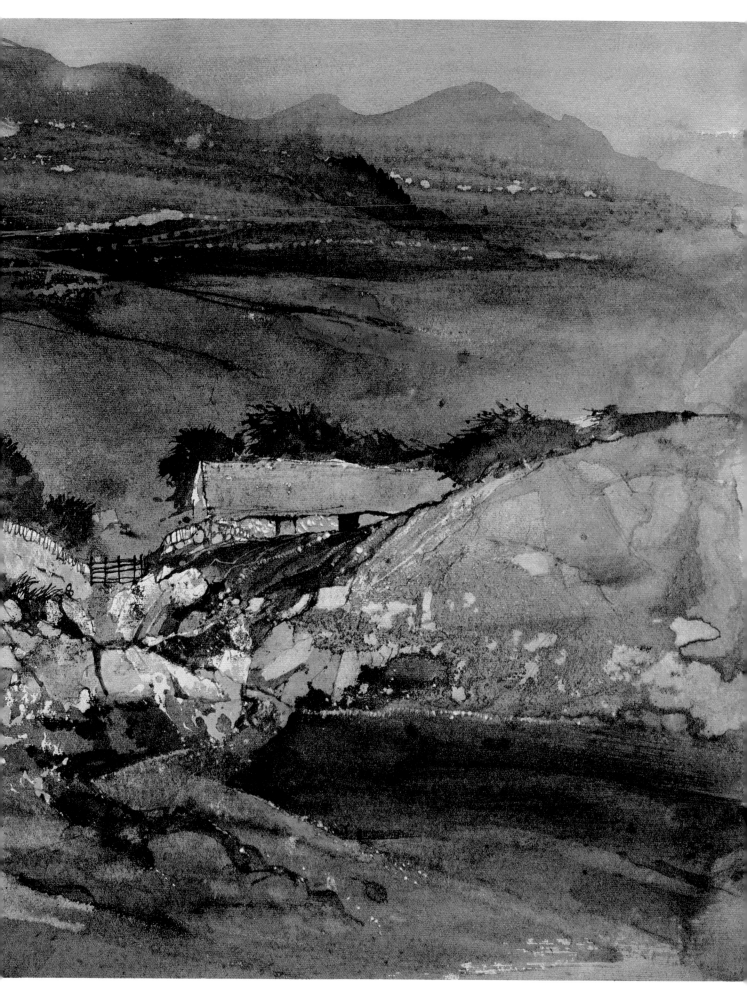

Creating recession through high and low-key colors

A COASTAL SCENE

When I climbed this hillside on the west coast of Scotland and looked down at the farm, with its cottages and one barn, the buildings seemed to lead into the ocean as if they were strung together. I felt a sense of endless space, as though the ocean continued forever. The coastline wound in and out, with many small islands, and in the distance, I could see the Isle of Skye.

Since I was concerned with recession in this painting, I "obeyed the rules" by having a dark foreground and progressively lighter background. I also enhanced the feeling of recession by painting a busy, textured foreground with only simple washes in the distance. I flouted the rules, however, by dividing my painting into light and dark values at the midpoint. While the rule of keeping such divisions unequal is generally sensible, I was able to break up the even symmetry of dark and light through the angular displacement of the buildings and the overlap of the islands. I also tried to distract the eye from the even divisions by creating a zigzagging effect with the angles of the buildings to divert the eye toward the water between the distant islands.

STAGE ONE

I outline the buildings first, putting down just a few pencil lines to describe their basic shapes and arranging their positions so their forms lead one by one into the distant water. Notice how the upper roofline is continuous from the barn in front to the two buildings behind it and to the smaller building in the back, and then seems to flow into the winding coastline of the islands. I paint the sky with a thin wash of cobalt blue, to represent the cool, misty atmosphere, then gradually lighten the wash as I bring it down over the sea, because the reflective surface of the water is even lighter than the sky. When the paper is nearly dry, I paint the distant islands with a single light wash of cobalt blue.

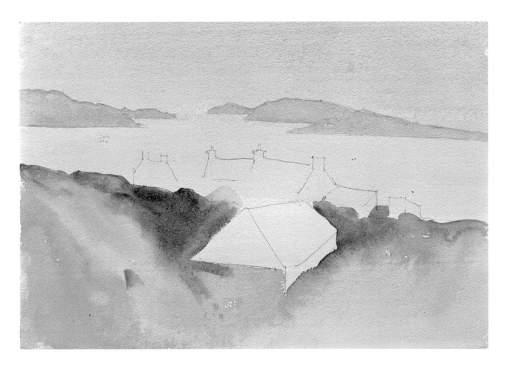

STAGE TWO

Now I begin suggesting the busy foreground with its softly blurred vegetation by brushing in a wash of pale Hookers green and adding darker tones of green mixed with burnt umber into it using a wet-into-wet technique. I use loose, curving strokes to suggest organic growth, but I am careful to paint around the barn and to leave the paper there white.

STAGE THREE

While the foreground is still wet, I work more darks into it, intensifying and bringing out the richness of the colors of the coastal farmland. The deep colors—phthalo blue, Hookers green, Paynes gray, burnt umber—give the foreground an immediacy and power that draws the eye. However, I prevent this area from becoming too dark and heavy by lifting color off with a brush. I also leave a trail of pale Hookers green around the barn to suggest the brightness and clarity of the scene. I work the brush in a sweeping motion to energize the foreground and to force the eye upward.

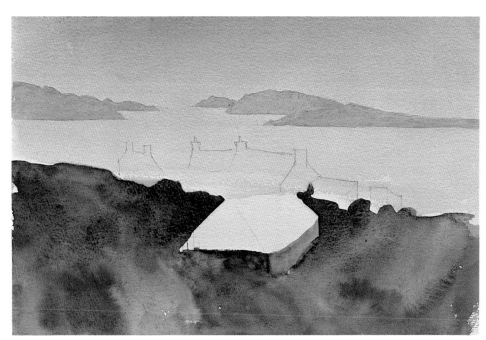

STAGE FOUR

I begin to describe the foreground elements by darkening the upper edge and dragging out several thin, diagonal strokes with a finely pointed brush to indicate grass. I also indicate a bit of grass in the upper left foreground with a pen. Then I lift dots of color from the front of the barn with the end of a brush handle wrapped in a rag. I define the stones on the barn wall with a stick dipped in watercolor and a fine brush, and I wash in the side wall with Paynes gray. With pen, I draw the lower edge of the barn roof and add some slats on the left-hand side of the gable. Then I pencil in a few more details on the buildings.

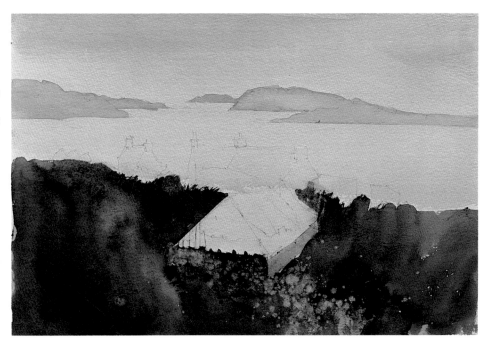

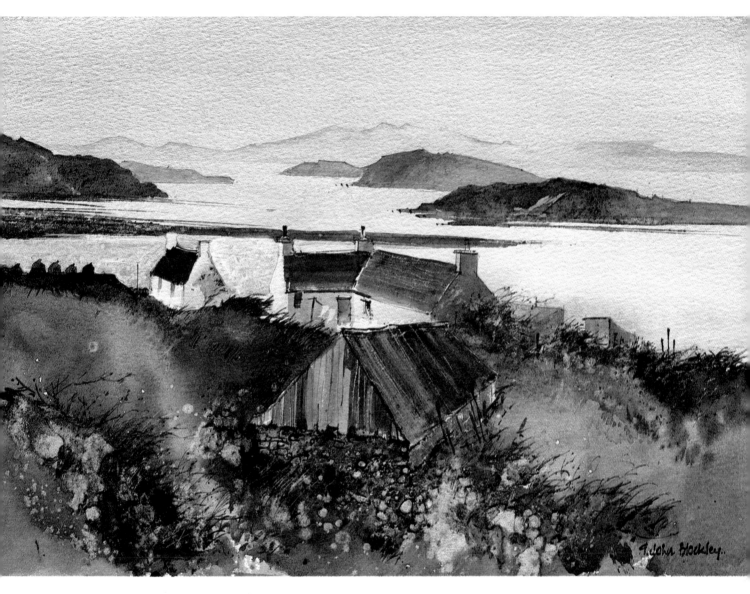

Coastal Farm, Erbusaig, 7″ x 10″ (175 x 255 mm)

To complete the painting, I brush in the final colors of the buildings and islands, and add foreground details with a pen and watercolor. To suggest the busy textures and stones in the foreground, I lift out more spots and define some of them with a pen. I also use a pen to draw the windswept grass, deliberately using a linear pattern that would give movement to the composition. I paint the barn roof with downward strokes of muted colors—burnt and raw umber, phthalo blue, Paynes gray, and burnt sienna. These vertical strokes of color encourage the eye to continue traveling upward to the light-colored sea and distant hills. Using the end of my brush handle, I also scratch some white lines into the roofs and down the barn gable to guide the eye into the picture. The lines also suggest the uneven textures of the buildings. With a very pale wash of cobalt blue, I indicate the distant islands, lightening them gradually as they recede. The small cottages in this region stack their hay in round heaps with a little twist on the top. I paint four of those haystacks on the hillside at the left, their silhouettes dark against the ocean.

Handling rough textures

TREES AND A ROAD IN WINTER

This rugged, lopsided dirt road led to a nearby farm where I would often paint. I especially liked to walk here during the winter months, when the trees were blotched with black and warm brown, and their wet surfaces reflected silvery patches of light that glistened within the somber tree colors. Sometimes those wet patches would make the edges of the trunks appear broken, as if pieces of sky had infiltrated them. Hints of ochre and ruddy brown, remnants of autumn, would also appear here and there along the road, adding to the overall mottled impression that the trees, dried grass, and road were all extensions of the same pattern.

In this scene I was particularly attracted by the harsh textures and harmonious colors and patterns of the elements. I was also intrigued by the imposing stance of the two large trees and the warm emotions evoked by the familiar road that led to a place I enjoy. I made a quick sketch of the scene and did the full painting when I returned to my studio. There I used a favorite studio technique of mine, dripping waterproof ink onto a wet wash, to achieve the dark, raw textures of the trees and road.

When painting rough textures, I often select a surface texture from one part of a subject and extend it to describe other parts. In this painting, I used the texture of tree bark and worked out a process for representing it. I also extended the process to describe the rutted contours of the road. I am always intrigued by the rough texture of some tree barks. I like to feel the roughness and, with my fingers, probe the deep grooves that break the scaly surface. I feel certain that their texture can also be used to describe the rutted road.

I used a variation of a traditional technique here and let a wash of color extend from one feature into another. In this technique, for example, a single wash of color may explain the light falling on a building and flood without interruption over the ground as well. This treatment contributes to the unity and feeling of continuity in a painting.

STAGE ONE

Sometimes I start a composition like this by masking the sky, for then I can brush color and add India ink without fear of spoiling it. But this time, because I am impatient and feel challenged, I decided to skip the masking stage. This means I have to be a bit more careful that the ink doesn't drip onto the sky (though sometimes—as you can see in Stage 2—such a happy accident produces a useful tree branch!). So after lightly outlining the two main tree trunks in pencil, I paint them with a light wash of burnt umber and continue the wash into the foreground. While it is still wet, I drop tones of Paynes gray and burnt umber into it. They blend softly into the first wash at the base of the trees.

STAGE TWO

My next step is rather daring. I want to give the trees and foreground a bold, intense, organic pattern—an effect I often accomplish by pouring black waterproof ink into a watercolor wash, flicking droplets of water into the ink to disperse it, and then partially drying the ink with a hairdryer to produce a blotched surface. However, before I take that plunge, I darken the trunks with Paynes gray to help me feel my way into the general form of the trunk. Having thus prepared the paper, and myself, I drip the ink into the wet trees and into parts of the foreground wash. By tilting the paper, I can induce ink to run the directions I choose. I must be careful that the ink doesn't break away from the wash and run across the sky, however.

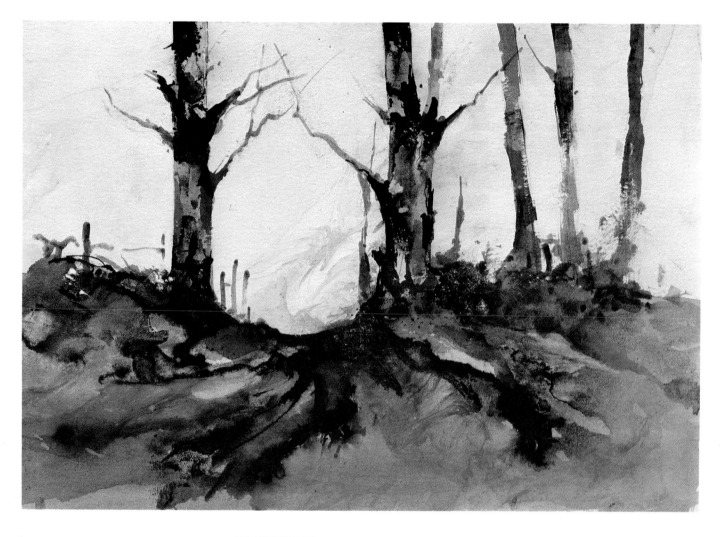

STAGE THREE

I create irregular patches by causing the ink to dry unevenly, dripping clear water into parts of it to keep it wet and drying other parts with a hair dryer. When I see that large blotches of ink are dry, I hold the painting under the tap, revealing the mottled tree and ground patterns I've achieved. I also produce grainy, white patches by gently loosening the almost dry ink by tapping it with my thumb, and then quickly flick the paper under the tap to wash away fragments of loose ink. Since my faucet has a short rubber spout, I can squeeze it between thumb and forefinger to direct a quick, sharp jet of water that will loosen the ink. The texture achieved depends on the dryness of the ink and the amount of water—and its force from the water faucet.

Next, I lightly indicate a few branches with a brush and watercolor. At this point, some of the ink loosened by the tap water can still be washed or brushed away, and so I continue to remove ink until I am satisfied with the pattern of darks and lights. Then I brush in a few more branches and other growth and indicate some fenceposts with a pen dipped in watercolor, and let the paper dry.

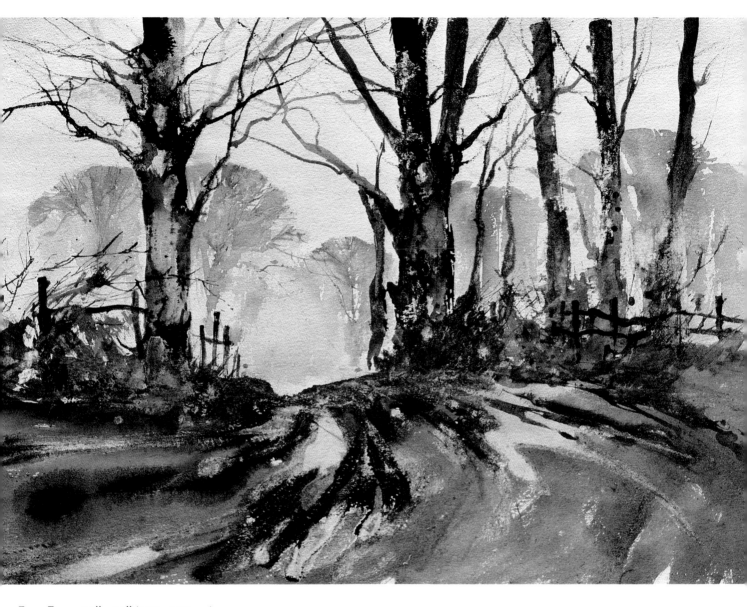

FARM ROAD, *10″ x 15″ (255 x 380 mm)*

To complete the painting, I redampen the paper slightly and brush in the distant trees with Paynes gray, using downward strokes, in various directions to give the trees their rounded tops. The soft treatment of the scalloped edges of the background trees brings the large foreground trees into harmony with the rest of the landscape and also makes the scene more gentle. With a fine brush, I quickly add the tangled branches of the nearby trees and bushes. I emphasize the energy of the tilted road by adding more earth colors with broad strokes that curve in the direction of the road.

Handling fine textures and patterns

A BARN DOOR IN A STONE WALL

This painting of an old barn door demonstrates my belief that you do not always need to look far to find interesting scenes to paint. Many times what is right in front of you, something ordinary that you've taken for granted, is actually full of interesting contrasts. Here I wanted to contrast the fine grain of an eroded stone wall with the hard smoothness of the windowpanes and the rough, weathered texture of the wooden door. To do this, I used a variety of techniques, choosing those appropriate to create the texture or mood I had in mind and even inventing new ones where necessary. For example, to suggest the finely grained surface of a stone wall, I used waterproof ink—but in a manner somewhat different from that of the preceding demonstration.

I was also fascinated by the interplay of lines and shapes: the rectangles of the window and door, the curved lines of the sagging lintel and long blades of grass, and the rounded shapes of the stones. I did not want to reproduce the exact forms I saw so much as to give the illusion of their movement and play with the patterns I observed. For example, I saw the six windowpanes as precise, square shapes in a geometric grouping and wanted to contrast this precise pattern with the random shapes and textures in the wall. Geometrical comparisons such as this one make useful starting points for paintings, and I have made many paintings on this theme—such as tattered newspapers with decorative lettering taped to the geometrical pattern of a brick wall or a single large window or door set against the fine stippling of a stuccoed wall.

STAGE ONE

Because I eventually want the windowpanes and parts of the door frame to be sharp and precise, I cover them with masking fluid before I begin to paint. I also mask a few lines to position the door and some odd shapes in the wall and foreground to indicate stones and patches of light. I limit myself to those areas I will clearly define in the composition. I plan to develop the rest of the painting gradually, working wet-into-wet to avoid competitive detail. For my first layer of color, I brush raw sienna, cobalt blue, and diluted cadmium red over the paper and let them blend. Those washes represent the playful impression I have of the lightest colors in the subject. I use horizontal and vertical strokes to establish the two-dimensional surface of the wall.

STAGE TWO
I strengthen the colors of the first wash while it is still wet to create a soft field on which I can build further textures. Then I indicate the dark tones of the door frame with burnt umber grayed with a little French ultramarine blue.

STAGE THREE

Working into the wet wash, I continue to add colors and begin to form a pattern of lights and darks, using the direction of my brushstrokes to give movement to the scene. I use broad horizontal strokes that sag slightly over the door to emphasize its old age. I use the end of my brush handle to scratch in some horizontal lines indicating the rows of stone. In the foreground, I let the patches of color bleed freely to create some organic movement. With a rag over my fingertip, I blot a few spots to suggest stones, and I try drawing two or three lines into the wash with my fingernail to indicate grass at the foot of the door.

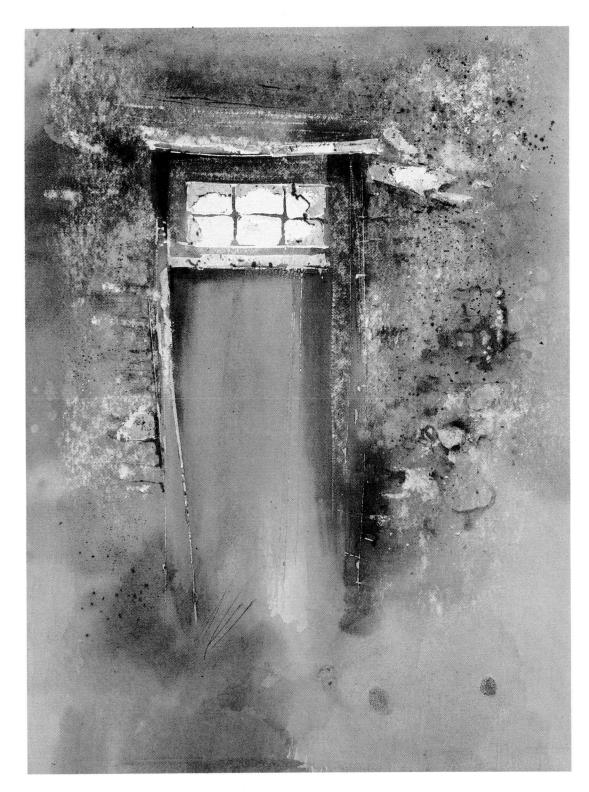

STAGE FOUR

While the paper is still damp, I continue to develop the surface texture. I blot washes with blotting paper and the end of a brush handle wrapped in a rag. I press new dots of paint onto the damp paper, and flick other fine, curved dots on with the tip of a springy painting knife. I dab some of these dots lightly and quickly with my fingertip to spread them, and texture other dots with the knitted hem of my jersey.

I produce the fine grain of the stonework by dropping black waterproof ink onto the wet color. But instead of drying portions of it with a hair dryer to create concentrated patches of ink as I did in the last demonstration, I gently rock the painting to cause the ink to separate into small fragments that settle on the paper and create a lightly speckled grain. Since the paper I am working with is unstretched and not clipped to a board, I am free to manipulate the ink in any way I want. For example, I can hold the paper in my hand and bend it; curl a corner to induce paint, water, or ink runs; or drain excess ink off the paper and onto the floor. Later, if the paper curls, I carefully stretch it after the paper dries, taking care not to rub the painting surface.

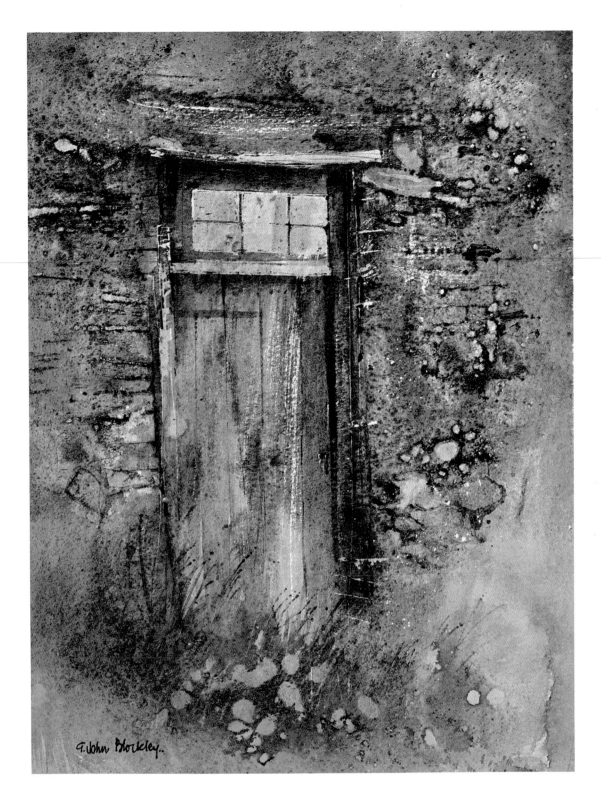

Barn Door, *10" x 13¼" (254 x 337 mm)*

I complete the textures on the wall by building up more dots and spots, outlining some of them to suggest stones. Some of the outlining is, in fact, a succession of dots made with watercolor on a stick pressed into the wet paper. The dots blend together and suggest a line. Then, with a fine sable brush, I add hints of the foreground grass and suggest the wooden boards of the door. The many rounded shapes in the painting suggest light reflections and express the evanescent and somewhat magical quality I see in the scene.

When the paper is dry, I remove the remaining masking fluid. I tint the door frame and walls to soften and blend their color into the picture and paint the windows with a thin wash of cobalt blue. My intentions are to have the light, sharper-edged window-panes attract attention first and to make the soft-edged eroded stone of secondary interest.

FARMS AND

Every part of the country depends upon farming in one form or another, and every locality has its own characteristic farm buildings. I have shelves of sketchbooks filled with farms from all parts of the countryside—woodlands, mountains, coastal regions, and moors. The drawings show broad landscape views, as well as close-ups of farm buildings, interiors, and details. Many farms, especially those in the wilder mountains and moorlands, are almost unchanged by time and have special attractions because of their great age. They are centuries old, built by hand with big, rough stones and are located in harsh countrysides where the soil is thin and punctured everywhere by rocky outcrops. These barely accessible places, where isolated farms look out over miles of undulating country, and where everything is heavily textured and rough, are my favorite painting grounds. The farm regions there are often rich in history and legend. And they have a special, almost forbidding, ambience.

It is not the farms, however, that attract me, but it is the strong contrasts of tone and color in the landscape that affect me temperamentally. Such contrasts suggest tensions, conflicts, and excitement, and they quicken my pulse. The deep tones in the landscape intensify the glitter of light on broken surfaces, and dark shapes explain light shapes—a black mountain, for example, frames and identifies a white cottage. Therefore, in my paintings, I respond to the landscape by em-

THE LAND

phasizing those strong relationships. I use a wide range of values, from light to very dark, and I place accents of bright color against washes of low-key color. For my palette, I seem to rely on a basic mixture of Paynes gray and burnt umber, using that mixture by itself to produce pewterlike grays, or converting it to bronze by adding a little brown madder. I also use the mixture to subdue tube colors—for example, to mellow Hookers green to a lustrous gray just hinting of green. I like to drift the dark tones through earlier washes of pale color to provide an atmospheric base for the vigorous patterns of the landscape. I aim to evoke an excitement or sentiment in my painting that matches the experience I had while at the scene.

My present home was once part of a farm. Cows were milked in it, and hay was stored in the barn that is now my studio. The buildings have interesting details, such as the door latch, made of hand-forged iron. Some of the older villagers still call my place the "cow-pens," a title I rather like. The hilly countryside where I live contains farms surrounded by woodland and slopes that are a patchwork of color. However, I prefer the uplands, where the farm buildings cling to the skyline, sheltered from the wind by only a few protective trees.

But farms everywhere are full of interest. They have form, color, texture, and odd details—to interpret in realistic terms, or to use as a starting point for your own painting experiments.

WOODLAND FARMS

In the lowlands, the plowed fields—chocolate brown and scored into glistening, buttery lumps—are interspersed among large wooded areas. The countryside there is relatively gentle compared to the mountain regions, but it does have its own textures, too. The bare plants have a brittle look in winter, which can be drawn with crisp flicks of a pen. The earth is crumbled, dirt roads are rutted by tractor wheels, and the texture of tree barks is pronounced. Because the soil is not an aggressive element in the landscape, the buildings seem large and have great importance. The tall trees provide a vertical foil to the horizontals of the buildings and land, and I like to paint the crisp profiles of the treetops against the sky. I especially enjoy the dignity of the elms.

Parts of the moorland and hill country are also heavily wooded. Sometimes a hillside is covered entirely with trees. Massed together so that their trunks and branches are not seen, they look like a continuous ripple of tone descending the valley toward the farms below. When I draw these woods, I use a thick stick of graphite on its side to sweep in the broad tree forms, and I complement those areas of tone against the more precisely drawn

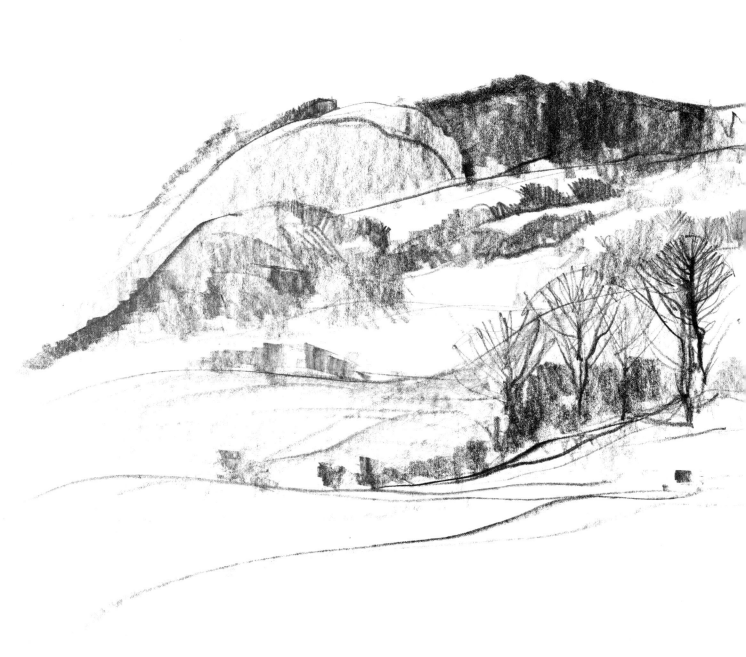

lines of the farm buildings. Most mountain and moorland farms have trees that were planted on their weather sides years ago, usually quick-growing sycamores.

I enjoy the woodlands best in winter, when the trees are bare and show their structure, their branches and twigs lacy against the sky and the ploughed earth sliced into buttery lumps. Sometimes the trees are a haze of tone; at other times their branches are crisp and angular. In my drawings, particularly, I try to capture their patterns and movements, and in my paintings I want to express the colors of winter. In winter, the woodland grass dries to tints of pale ochre that appear warm against the distant blues, and the color of the trees is sometimes strong and intense and, at other times, a blend of subtle grays.

In summer, the trees are in full leaf and form a rich, dark curtain behind the buildings, their dark masses surrounding and explaining the lighter shapes of the man-made structures. Patches of sky that appear within the larger mass filter a soft light over the rugged stone walls of the farm, and their negative shape creates a pattern against the sky.

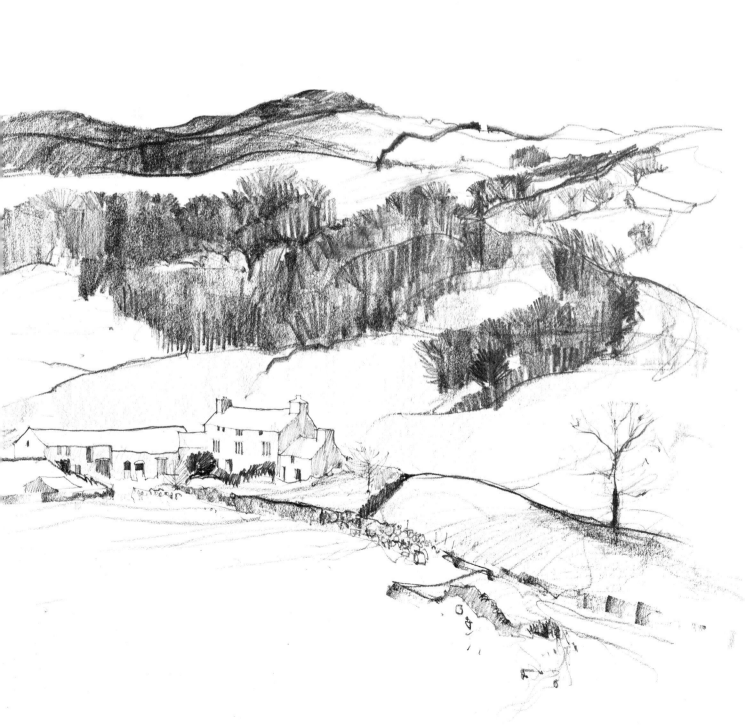

Expressing spring light
with a wet-into-wet sky

FARM POOL, 8¾" x 11¾" (222 x 298 mm)

I was particularly attracted to the lighting in this scene, for it gave every color a fresh vitality and every edge a crispness. It was one of those days of frequent rain with breaks of sunlight. The sky was still full of dark clouds—pewter, almost black, in color, yet the lower sky promised sunshine. Already the scene sparkled with light reflecting from wet surfaces.

I normally cover the entire paper with an underpainting of diluted color and work into it with wet-into-wet washes. But this time I worked each part directly onto the dry paper so the white sparkle of the paper would show through. I modeled the clouds with various tones of Paynes gray, softening the edges with a moist brush and leaving an occasional hard edge on the white paper. When the paper was dry, I painted the background mass of trees in a continuous movement, brushing a wash of Hookers green—with burnt umber and Paynes gray for tonal changes—in organic patterns across the page, shaping the lower edge of the woods around the farm buildings. In some places I softened the treetops with a moist brush, but in others, I kept the treetops hard-edged and dark against the light sky. This treatment—using hard edges and sharp contrast in one area, then softening the edges as the tonal values become similar—gives bite to a painting.

I brushed a wash of yellow ochre into the middle ground to show the sunshine coming out and to draw attention to that area of main interest. Then I painted the foreground with burnt umber into which I brushed Paynes gray, forcefully using an oil painter's bristle brush to press the dark horizontal strokes into the paper. I painted the water with cobalt blue and repeated the color in the smaller, secondary buildings. The large barn was an attractive focus point, and I painted its roof with cadmium red. In this painting, little flickers of white paper appear, the result of using a dry brush, purposely leaving unpainted spaces, and scratching away color. Normally I avoid this technique because, if overdone, the white specks can make a painting look too busy. However, this time I needed those glints of light to convey the feeling of spring sunshine.

SUGGESTED PROJECT
Try to capture the feeling of spring light sparkling over a landscape, working on cold-pressed or rough paper. Work directly on the dry paper with final washes of color and leave specks of white paper in several areas to give the effect of light. Select your colors with care, choosing those that best express the tone of the day, and contrasting light colors against dark ones to convey the sensation of bright sunlight.

Describing strong summer sunlight

Deserted Farm, 8″ x 10½″ (203 x 267 mm)

I had been painting unsuccessfully all day. Dispirited, I flicked through the pages of a sketchbook, picked up a piece of paper, and this little watercolor seemed to just happen. I wanted to recollect the farm buildings and the long grasses waving in the bleached summer light. The scene has a grayish cast, partly because of the harsh summer light and partly, perhaps, because of my mood. But the painting has freshness; and I packed up for the day in a better frame of mind.

I obtained the light in this scene, as in *Farm Pool*, by working directly on dry paper, letting specks of white paper show through. I also used a yellow ochre underwash for the sunlit field. However, I used thinner washes and less intense colors here than in the spring scene opposite to describe the bleaching effect of the summer sun. I painted the fore-

ground wash quickly, in short, crisscrossing strokes to suggest roughly tumbled grass. I used the same gray green mixture for the trees and grass to harmonize the painting, and the yellow ochre in the middle distance balances the weight of the house and provides a crisp accent to the landscape. I added textural interest by giving the stone barn wall a mottled surface, achieved by blotting, and drew thin, waving lines of grass to accentuate the moist foreground. The vertical lines of the painting all lead to the central farmhouse, the center of interest.

SUGGESTED PROJECT
Use the same techniques as those suggested in the preceding project, but this time try to describe a hot summer day.

I made full use of my pencil to suggest the linear movement of the trees and bushes and to describe the closely spaced branches spread in their fanlike shape. On the other hand, I used very little pencil work on the roof so that the drawing in the trees is emphasized. I find pencil particularly well suited for representing the many textures and patterns of bare branches against the sky. Pencil lines can be hard or soft, thin or thick, twisted, waving, sharp, or feathery—depending on the character of your subject. In winter, the sky can be seen as many tiny shapes between the branches, and the hard light filters through fairly evenly. Compare the atmosphere of this drawing with that of the painting on the next page, where the bright summer light is softly diffused through the foliage, and concentrated areas of light occur in irregular patches. Of course, the difference in medium will affect your response, too!

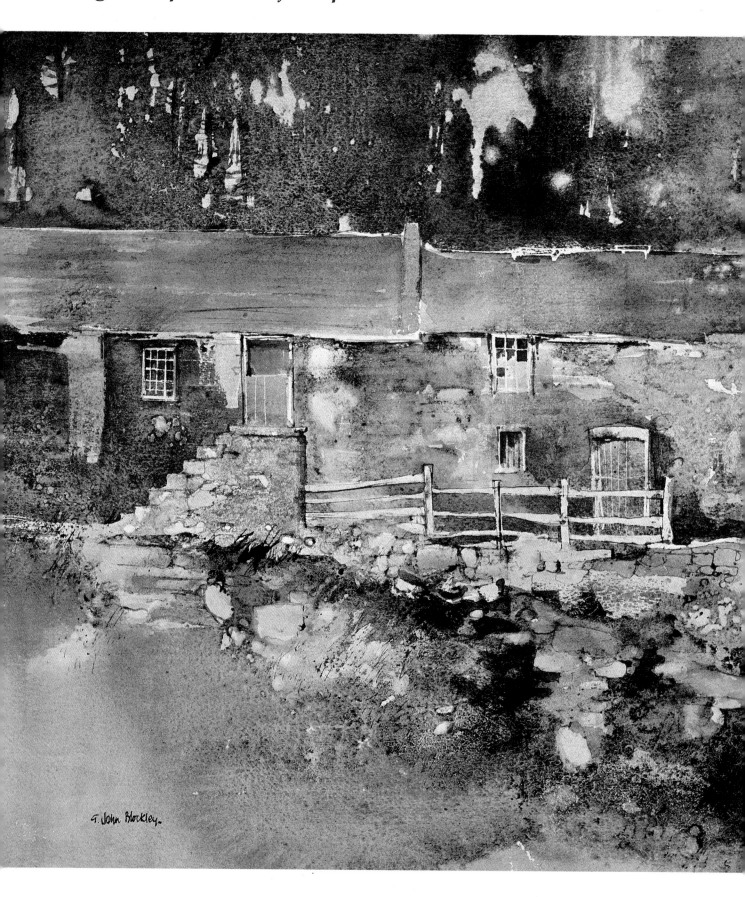

G. John Blockley.

Stone Barn, 14½" x 20" (370 x 510 mm)

In this painting I tried to express the effect of the bright, quivering light that came through unseen foreground trees and its dazzling effect on the harsh stone walls. The intense, spotty light melted sharp edges and its strong glare whitened the colors.

Although the immediate image here is of a typical stone barn, the interest in the painting depends largely on the repetition of the same shape, a rounded rectangle, to create a subtle, underlying rhythm that holds the painting together. This shape is repeated discreetly in the shapes of the sky holes, the texture of the barn, the holes of the fence, and throughout the foreground rocks and boulders. All these shapes are softened and blotted and all are the same pale color, but some shapes are slightly firmer with hints of an outline, while others are barely visible, and still others are boldly outlined. I also spaced them with an eye for variety: some shapes are isolated, others cluster and merge, and some recognizable repetitions occur as these egg shapes are tilted at the same angle. The soft skylight shapes in the background trees also repeat the basic pattern.

I protected some of the hard-edged details—windows, doors, fence, and some stones—with masking fluid, then washed cobalt blue over the sky area. When it dried, I painted the background trees, leaving sky holes in several areas. When the paint was nearly dry, I splashed clean water into it with a brush, waited a few seconds for it to diffuse the paint gently, then blotted up the color by wrapping my finger in a rag. This gave the sky a soft-edged quality and created the effect of strong light filtering through the trees. I used the same technique in the foreground. There the blotted areas suggest small stones and shimmering patches of sunlight, while the unblotted areas—where the water simply repelled the paint in soft, mushrooming shapes (see the lower left, for example)—describe the soft textures of the earth.

The process of applying clean water to a painted area that is nearly dry breaks all the standard rules of watercolor because it involves tampering with a wash at a very fickle stage. The risk is that the splash of water might disturb the nearly dry pigment and deposit it as an unpleasant water stain. That, however, is a risk I am prepared to take, even at the expense of losing the painting. As I said earlier, it is better to take a risk than to be timid and compromise your painting.

SUGGESTED PROJECT
Try to see how many similar shapes you can find in a landscape, and create a painting with that in mind. Be careful to vary the shapes slightly and to space them in interesting ways to avoid a too-obvious repetition. The viewer should be aware of an underlying rhythm in your painting without necessarily knowing what has caused it.

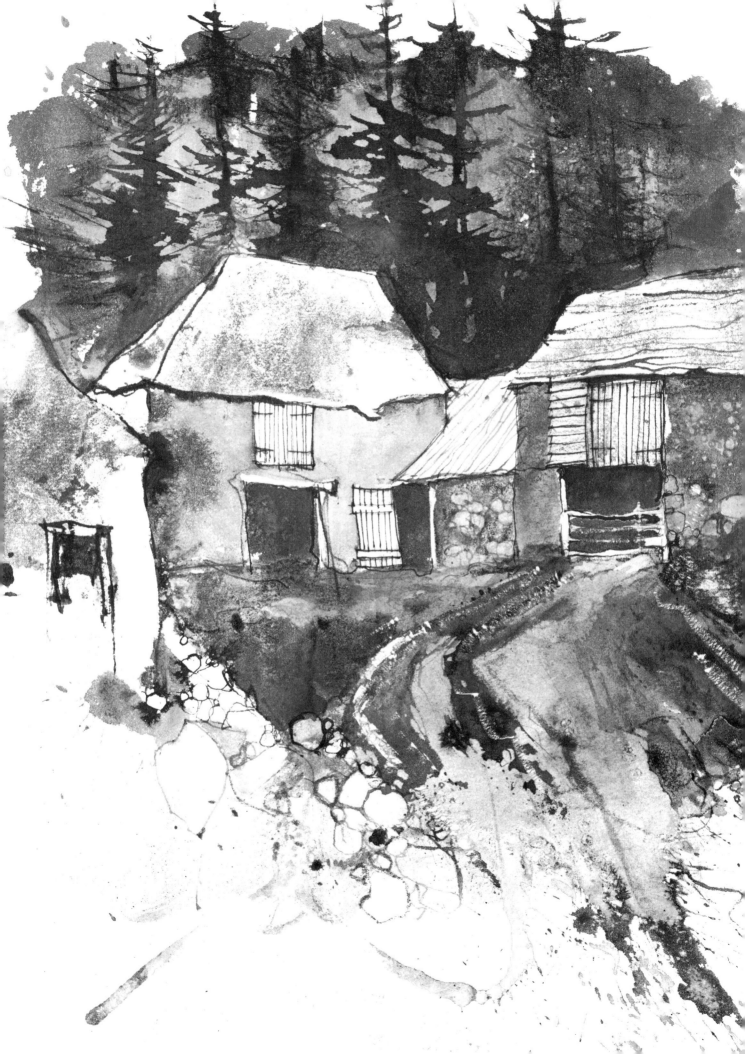

This is a quick sketch of a farm at Dartmoor. I was attracted by the shape of the roofs and their staggered planes against the dark mass of background trees. I sketched the roofs quickly with a piece of sharpened stick dipped in ink, and then I washed and splashed lampblack paint over the dark areas—the information in a sketch can be quickly extended by adding a wash of paint. I blotted out textures with a piece of paper and with the sleeve of my jersey. I drew the trees with slashing strokes of my brush while the background was still damp. The roofs were kept mostly white, sandwiched between the dark foreground and background to call attention to them.

The sketch is hurried, rough, and crude, but it does convey something of the character of the place. Afterward, I sat with the farmer in his kitchen, drinking rough cider from an enamel mug. He shook his head gently and sadly as he looked at my drawing. "You could try again," he suggested.

Contrasting high-key buildings and shadowy trees

COTSWOLD FARM, 8" x 9" (203 x 228 mm)

I was attracted by the contrast of the warm, dark trees against the cool sky and the relationship of the tall elms to the long horizontal wall and the farm building. The perpendicular dynamics of the scene were striking, and I positioned my subject on the page so that the L-shape made by the house and trees was matched by an L-shaped sky. The rectangularity of the scene is relieved by the spreading tree branches. To call attention to the intricate pattern of the treetops, I painted the building and sky simply, with a minimum of description.

I painted these trees in three stages. First, I put down a simple pale wash for the sky. Then I studied the structure of the trees and their main shapes and fixed them in my mind. While the sky wash was still moist, I painted the shapes of the trees without looking at them again, using cobalt blue slightly warmed with burnt umber, dragging the side of the brush over the paper to leave sky holes within the wash. I used muted colors left on my palette (yesterday's paint) to add hints of other colors within the brown. Finally, when the background washes were nearly dry, I added the trees, painting the trunks and main branches with a brush and the finer branches with a pen dipped in watercolor. Since I was not looking at the trees, the branches I drew were free and loose, expressing character rather than exact form.

SUGGESTED PROJECT

Paint a farm or house that attracts you. Try to see it, not as a house or farm, but as an abstract shape. In fact, try to get into the habit of seeing most literal objects as abstract shapes. I know there are trees and buildings in this painting, but I never think of them as such when drawing or painting. Here, for example, I saw the roofs as solid, dark shapes; the trees as rounded shapes; and their branches as an open filigree pattern traced against the light sky.

Framing a painting with trees and a curving path

FARM AT TADDINGTON, COTSWOLD, *8" x 10" (204 x 255 mm)*

As I walked along the dirt road leading from the fields toward the farm, I noticed that its curving path led the eye to the gate and directly to the rounded door in the building. The tall trees made a ready frame for that area of interest, creating a small picture within a larger picture. To emphasize the entrance into the smaller picture, I deliberately kept the road light in value as it neared the gate and, instead, darkened the walls on each side. I also sharpened the edges of the road there to further emphasize the passage from one space into the next.

Even when the leaves are gone from the trees, in this part of the country you still find the contrast of warm colors against a cool sky because the farm buildings and walls are built with a warm-colored stone that harmonizes with the ground. I painted the farm building in two washes: a pale yellow ochre for underlying warmth, and when the first wash was almost dry, a thin layer of burnt umber to give the walls body and subdue their brightness. I painted the trees lighter than they actually were because I wanted to include them without detracting attention from the buildings. So, although the tree trunks were very dark, I painted them with a relatively pale wash and added only a few dark patches to indicate their color and texture. I used a fairly dry brush for the trunk as well as the branches, and I drew the twigs with a finely pointed brush and a brushstroke that could be described as a downward turn followed by a quick lift-off motion. The dry brushwork left ghostlike lines that disappeared into the sky.

SUGGESTED PROJECT

Paint a landscape where the foreground plays an essential role in directing the eye to the background—the real subject of the painting. Keep the foreground interesting but through careful selection of edges and lines, or with contrasting background colors and values, try to control the viewer's attention and eventually get it to settle on the center of interest.

MOUNTAIN FARMS

Nothing thrills me more than being in the mountains on a wet day. I am reputed to have said—and it is something of a joke with people who know me—that I prefer to paint in the rain. I do enjoy the enhanced colors and tones the rain produces: the ochres, greens, siennas, and steely grays of the mountainside become even darker and richer. Before the rain, the sky deepens to a blue-gray color—I think of Paynes gray—and rock surfaces are highlighted. Then, during the rain, the moving clouds veil and momentarily unveil the mountain peaks. You might mentally paint them as you watch. Afterward, the rain-washed sky takes on an intense brightness, and the blue-black mountain shapes are sharply profiled against it. The mountain crest has a distinct, sensitive edge, a line that—with its dips and rises—bounds both the sky and mountain. Notice, in fact, that the two shapes, sky and mountains, are inversions of each other.

The immensity of the mountains and the sheerness of the rock faces are offset by the smaller, looser patterns of the lesser slopes. The effect of weather on the landscape is more apparent in the mountains than in other areas. Bare rock exposed to the wind and rain erodes quickly, and the mountain surface is continually breaking up and moving down, littering the slope with rock debris. The rocks are spattered with lichen, tree roots twist and turn in the crevices, and veins of quartz appear on the surface. These vibrant textures

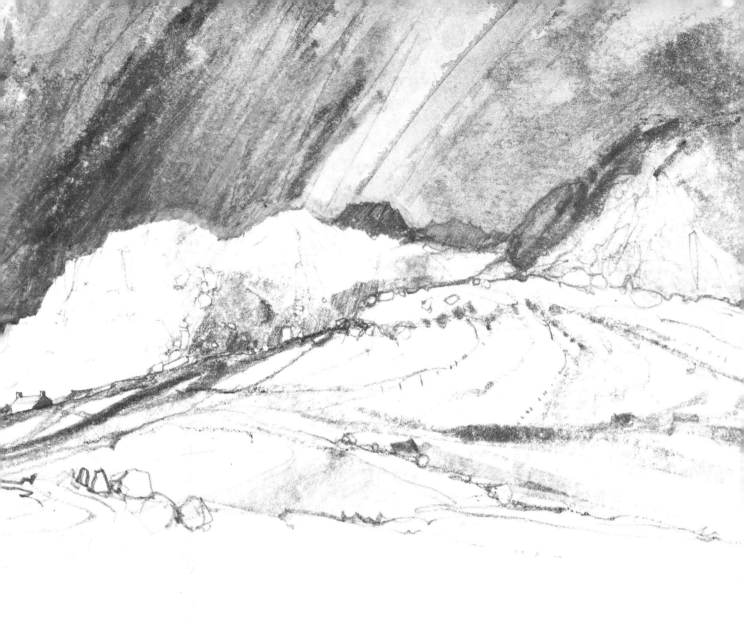

are, I believe, what first induced my experimental painting techniques. Among other techniques, I have found it useful to let wet paint run, creating naturally meandering outlines for rock formations. I also like to drop waterproof ink onto the paper to express large patches of lichen, and I often let the texture of ink sediments represent the grainy surface of the rock itself.

In contrast to the dramatic mountainside, the farm buildings are simple constructions, solidly designed to resist the weather. They are all built of local stone. Some stone buildings have been left in their natural state and blend into the mountainside, while others have been whitewashed and appear brilliantly sharp against the dark mountains, especially in the black mountain areas of Wales. The hard-edged, geometrical shapes of these buildings echo the angular outlines of rock forms and stone slabs. In my mountain paintings, the farm buildings have less importance than the powerful landscape.

You will find that the scale and vigor of the mountains inspire the use of energetic colors and lines, with diagonal movements countered by the horizontals of farm buildings. There is nothing tentative about the mountain landscape, so you must work boldly. Use big brushes and positive action. Then, couple that strong treatment with the sensitive drawing of details.

Mountain textures and colors
on a clear day

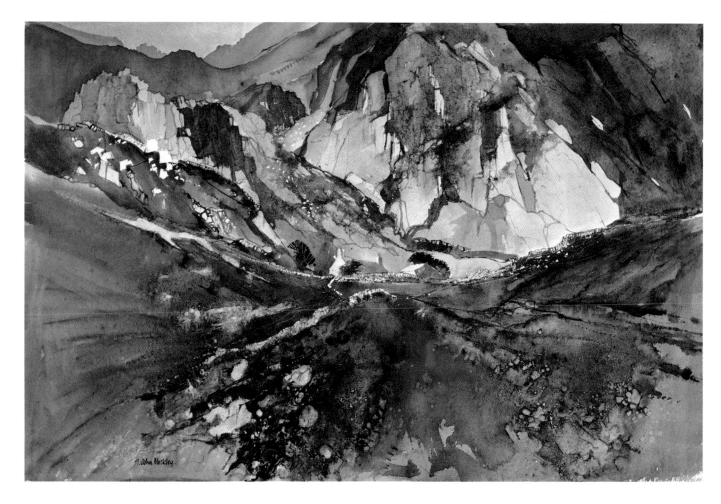

LLANBERIS PASS 1, *15" x 21" (380 x 535 mm)*

The paintings on this page and the next are interpretations of the same subject under different weather conditions. I painted the view of Llanberis Pass shown above on a day when the mountaintops were clear of clouds and the smooth faces of the huge, vertical rocks reflected the light. I concentrated on the detail of these rock faces and deliberately subdued the treatment of the smaller rock debris on the lower slope of the mountain.

The painting was done with washes of color that ranged from the intense colors of the wet foreground to the delicate, blue-gray color of the distant mountains. The hard-edged outlines of the rock faces were drawn with pen and diluted watercolor after I applied the washes. I obtained the fine-grained texture in the foreground with my waterproof-ink technique and drew soft, brown streaks on the left with a stick while the washes were still wet. The yellow ochre color of the central area radiates like a star over the landscape, while the green of the foreground glides from left to right in a curve that supports the major rock formations. The unifying upper boundary is provided by the Paynes gray and cobalt blue wash of the distant mountains and by the burnt umber on the right. The umber ties the picture together and encircles the light-reflecting rock. Note how the light value of the two rock formations makes them stand out against the darks as areas of main interest. The dark tones begin in the upper right-hand corner and fall from there to sweep across the foreground like a protective arm curved around the massive rocks.

SUGGESTED PROJECT
See how many ways you can interpret the same subject. Paint an indoor subject from different angles or under different types (and colors) of lights. Paint an outdoor subject under different lighting and weather conditions, or at different times of the day. Whatever your subject, look for its essential characteristics at these particular times and try to express them in your painting.

Mountain colors and textures on a misty day

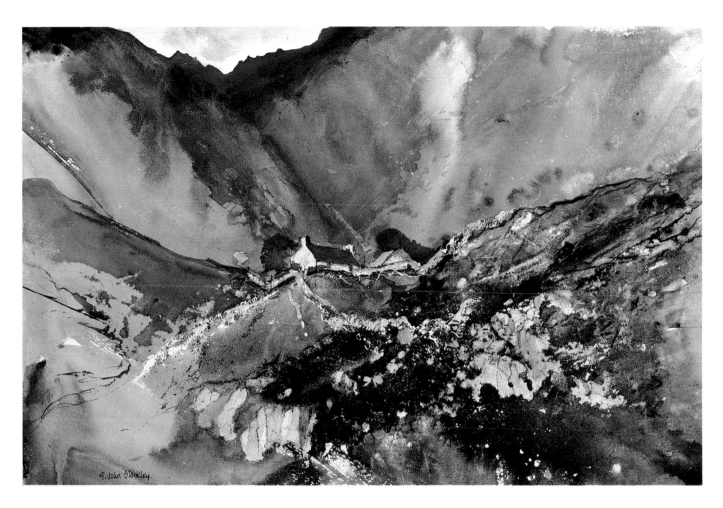

LLANBERIS PASS 2, *15" x 21" (380 x 535 mm)*

In contrast to the painting opposite, in this view of Llanberis Pass rain clouds drift down the mountain face and rock details are lost in mist. I painted the mountaintop wet-into-wet to create this atmospheric effect. On the other hand, where the air is clear—below the farm, where the rock debris slopes steeply downward—I used strong tonal contrasts of black and the palest of grays as a foil to the atmospheric treatment of the higher areas. This time it is the darks rather than the lights that signal my areas of interest: first, the large patch of gritty foreground rocks; second, the silhouette of the mountaintops; and lastly, the cottage with its dark roof.

I deliberately simplify the background to increase the soft, atmospheric effect while keeping the foreground elaborately textured because it is closer to the viewer. A pale wash of cobalt blue with a touch of yellow ochre gives the sky its color and provides a cool underwash for the mountainside and the foreground. I worked the soft grays, blues, and browns of the mountain into it, adding hints of yellow ochre and cadmium red to the land. A broad stroke of burnt sienna defines the foreground slope on the left and rises in a supportive curve that acts as a backbone to the composition. I blotted the foreground with a rag to suggest coarse earth textures and suggested a long, cloudlike shape on the mountain wall with a moist brush. I obtained the harsh, dark textures of my center of interest, the foreground rock debris, with my watercolor-ink technique.

The symmetry and balance of this composition is less evident than in the preceding painting. The strong movement here is a zigzag that descends from the bright sky to the cottage, then runs left and right in the foreground. This angular movement, plus the jagged lines of the central ridge and the diagonal stone walls, gives the picture a sense of unrest and evokes the changeability of the weather.

SUGGESTED PROJECT
Paint a scene that suggests a rapidly changing weather pattern. How would you suggest it?

Expressing mountain slopes as abstract lines

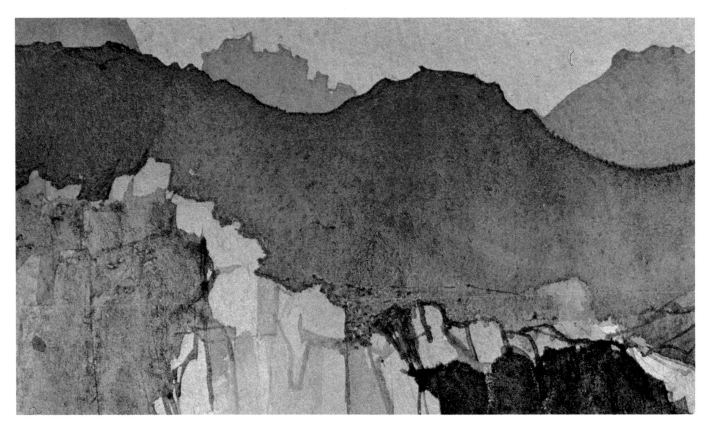

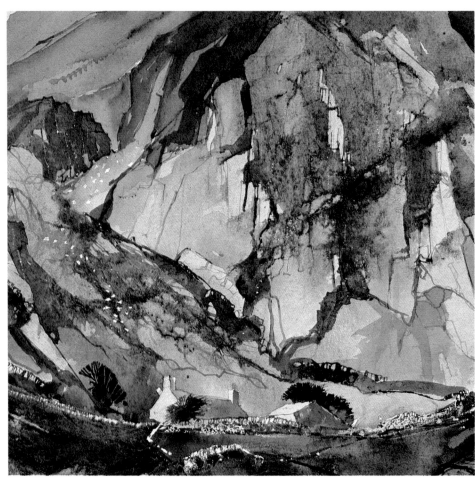

LLANBERIS PASS 1 *(detail)*

I created the rock face by applying wet-into-wet washes for the softly dispersed violet and browns, and the soft yellow area; and wet-onto-dry washes for the cutout, collagelike shapes. The tilted paper encouraged thin streams of paint to run down and form convenient outlines of the rock formations. For the most part, I made them vertical but on the yellow slope, where I wanted a gentler movement, I created diagonal runs.

I used several diluted colors to express my response to the cool, but attractive, rock face, but I kept the colors within the same value range to maintain the unity of the image. You must look for rich colors when you look at mountains. If you can't find any, imagine them—don't confine yourself to thinking of mountains merely as brown or blue.

SUGGESTED PROJECT
Paint a mountainside realistically. How many colors can you see in it? Are they only warm or cool tones? What colors are in the shadows? This project will develop your color perceptions so that, with experience, your eye will discover color nuances that you've never noticed before.

Describing rocky soil as abstract patterns

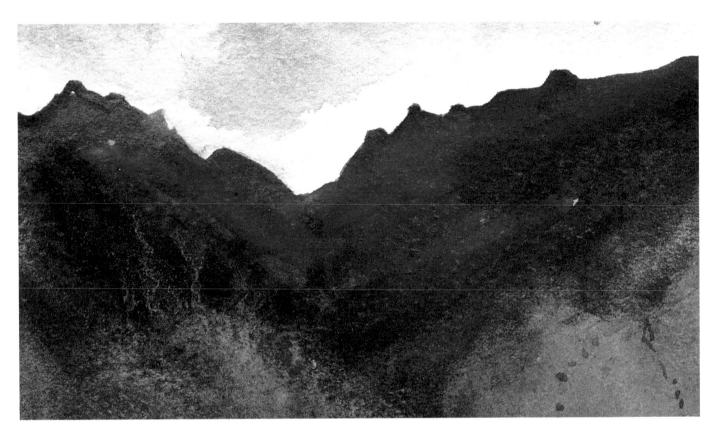

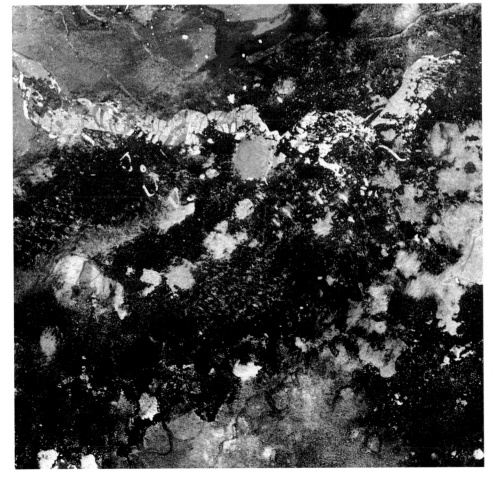

LLANBERIS PASS 2 *(detail)*

This painting was done as a class demonstration. Inspired by a drawing from my sketchbook, it took only an hour to complete. The heavy, scattered texture of the black ink, with its hard edges and high contrast, suggests rocks only when you realize that the scene is a landscape. But taken out of context, as here, this area of the painting becomes an abstract, organic world of its own. That liberty to express and create within a structure that, taken as a whole, represents a real subject is something you should exercise whenever you paint.

SUGGESTED PROJECT
This time paint a mountainside abstractly, in a linear fashion. Can you still tell that it is a mountainside? Why? What gives a mountain specific characteristics of its own?

Painting coarse mountain textures
with granular washes

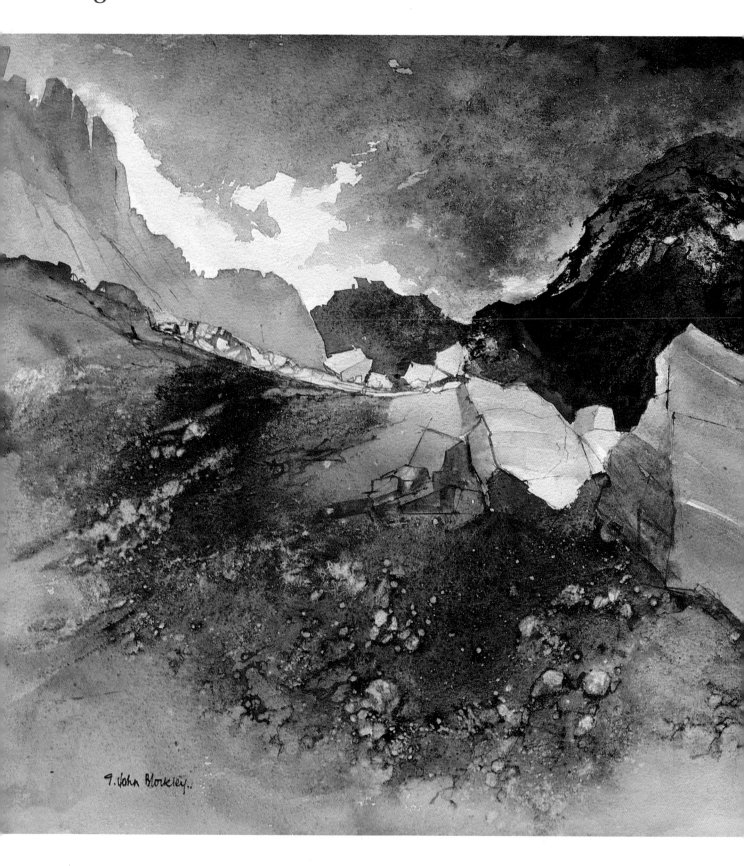

9. John Blockley..

LLANBERIS ROCKS, *15" x 21" (380 x 535 mm)*

The coarse textures of the mountain, emphasized by the smoothness of the rock slabs, attracted me to the scene. The fallen rocks varied from fist-sized stones to the huge sentinel standing in front. Needless to say, it was raining, and so I huddled under a rock to make the drawing shown above, from which I later developed this painting.

I covered the big foreground rock with masking film, cut out with a sharp blade, because I wanted a precise, hard edge on the rock. Then I painted the sky and mountain with Paynes gray—with lampblack and burnt sienna added for traces of warmth. I obtained soft foreground textures by blotting the still-damp washes with a rag wrapped around the end of a brush handle, or my fingertip. I also produced a faintly mottled surface on the dark mountain by momentarily lowering a piece of absorbent newspaper onto the nearly dry paint. To simplify the composition, I omitted a number of boulders from this painting, and included only those that led the eye deeper into the picture toward the light patch of sky in the distance. I drew the dark lichen that clung to the slopes with a stick dipped in lampblack watercolor, then brushed a black wash in a curved path over the mountain, subduing the rich colors underneath and creating a consistent, dark backdrop for the light, hard-edged slab in front. The string of hard-edged rocks that cross the painting diagonally provide a link between the large rock and the jagged mountaintop.

SUGGESTED PROJECT
Paint a landscape in the rain. How can you show that it is raining? To guide you, consider the direction of the brushstrokes in suggesting rain and try stiff-bristled brushes. Remember that some edges will be hard and others soft. These are called "lost-and-found" edges.

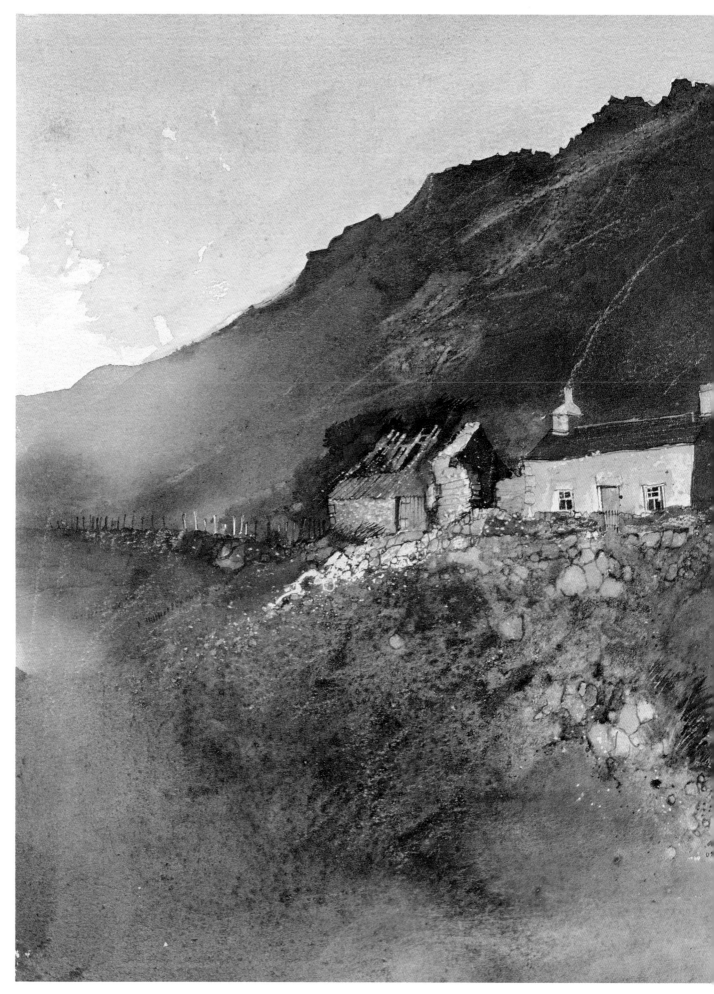

Achieving texture through granular washes

COTTAGE BENEATH THE MOUNTAIN, *12" x 14½" (305 x mm)*

The principal characteristic of this cottage is its solid-looking shape: the chunky chimneys and the positive, functional, symmetrical placement of the windows on each side of the central door. The cottage seemed to stand with authority, plumb beneath the mountain, and it seemed vital that I paint it so—in the middle of the paper, and very white, hard-edged, and contrasty against the dark mountain. The foreground boulders were important, too. They curved downward, away from the cottage, and terminated in rounded, white shapes that counteracted the formality and centrality of the chunky cottage.

In this painting I relied more than usual on the granulation of watercolor pigments to achieve interesting variations in surfaces. By rocking the paper as it dried, I caused the dark foreground paint to congeal, resulting in a mottled surface. And I blotted it to obtain lighter mottled areas and then balanced that flocked texture with clean, simple washes elsewhere.

For the textured wall, I masked the cottage and stone wall on the left with masking fluid. When it was dry, I rubbed the wall area with my finger to create small holes in the masking skin. When subsequent washes of color penetrated this area, they created the effect of a crumbled wall. I washed the mountain with a weak wash of Paynes gray, into which I dropped a little brown madder, alizarin crimson, stronger Paynes gray, Hookers green, and a little burnt umber. Then I rocked the paper slightly to cause the burnt umber to become mottled and blotted out stones in the foreground. Finally, I rubbed off the masking fluid, tinted the buildings with Paynes gray and burnt sienna, and added details with pen and watercolor.

SUGGESTED PROJECT
Place your subject at the center of your paper—then arrange the rest of the composition to make it interesting.

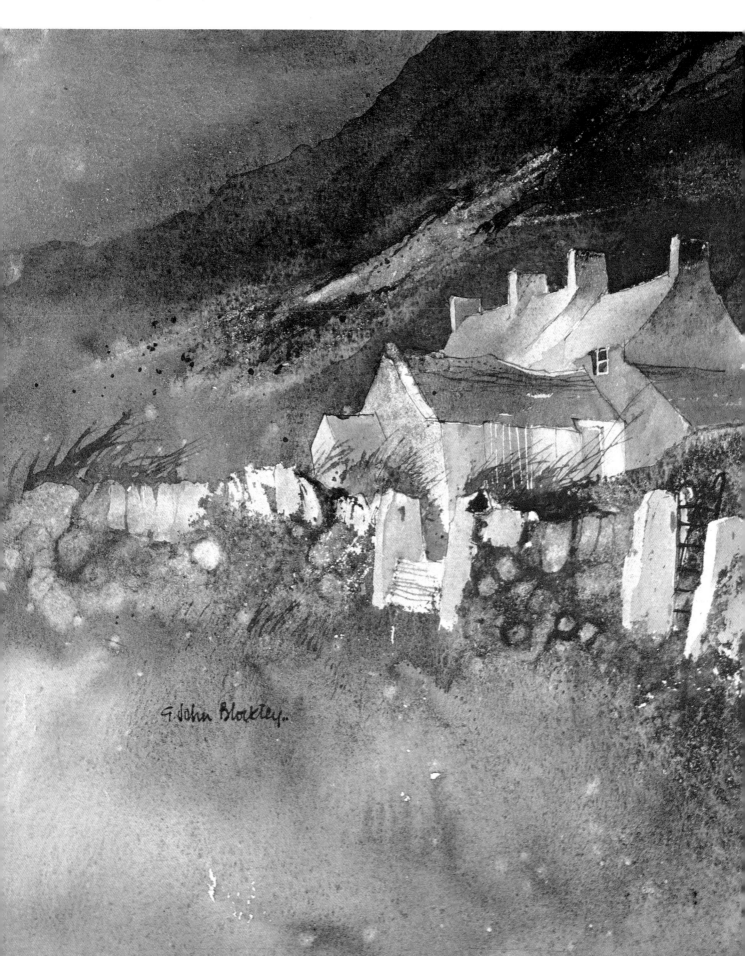

G. John Blockley.

Uwch y Gors, 11½" x 15"
(290 x 380 mm)

The light on the building and stone gateposts was my main interest in this painting (shown above and on the preceding pages) and I intensified it by surrounding it with dark tones. The simple treatment of the background and foreground allowed the clean colors and geometry of the building to be noticed. I worked the mountain in broad, wet washes, gently sweeping my strokes upward to give the setting its mystical atmosphere.

I masked the lightest area, then brushed Paynes gray over the paper, diluting it at the bottom of the paper and blending hints of warm burnt umber into it. I also added a strong mix of burnt umber and lampblack. By rocking the paper as it dried, I caused the burnt umber and black to separate, creating a granulated texture. (This is a useful process, but don't let it become a gimmick.) Before it dried, I blotted out some soft-edged stones with my fingertip, wrapped in a rag. When the paper dried, I rubbed the masking fluid away, and lightly tinted the building and gateposts with cadmium red and yellow ochre. I also added a little dark color to define the hard silhouette of the mountaintop.

SUGGESTED PROJECT

Look at a subject and select an abstract quality that interests you. Then use this selected quality as the key to the painting. It might be a certain texture, or, as in the two paintings on these pages, a quality of the light. The light is silvery here, perhaps caught by only a few rock surfaces, but it became the basis for these paintings. I extended the silver fragment that caught my eye to cover all the buildings. I also intensified the effect of the light by surrounding the buildings with a dark, almost black tone. Determining a particular quality and investing the whole of the work with it can create interesting possibilities for experimentation.

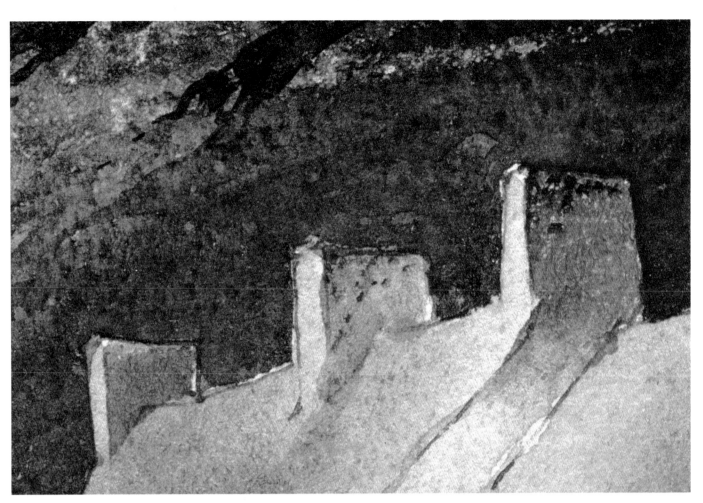

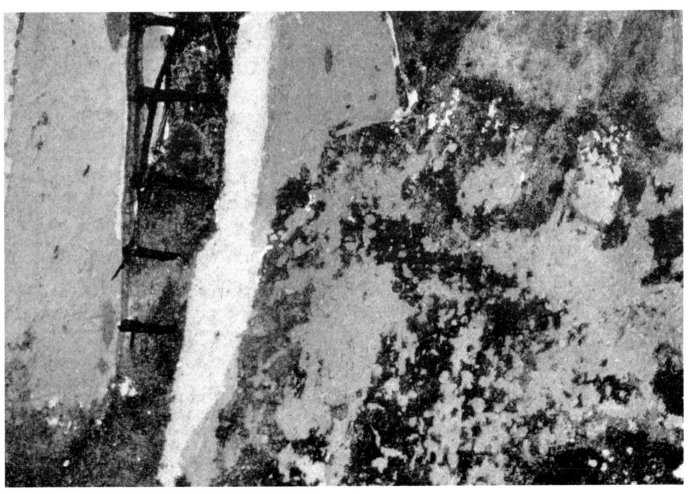

Handling texture in dark areas

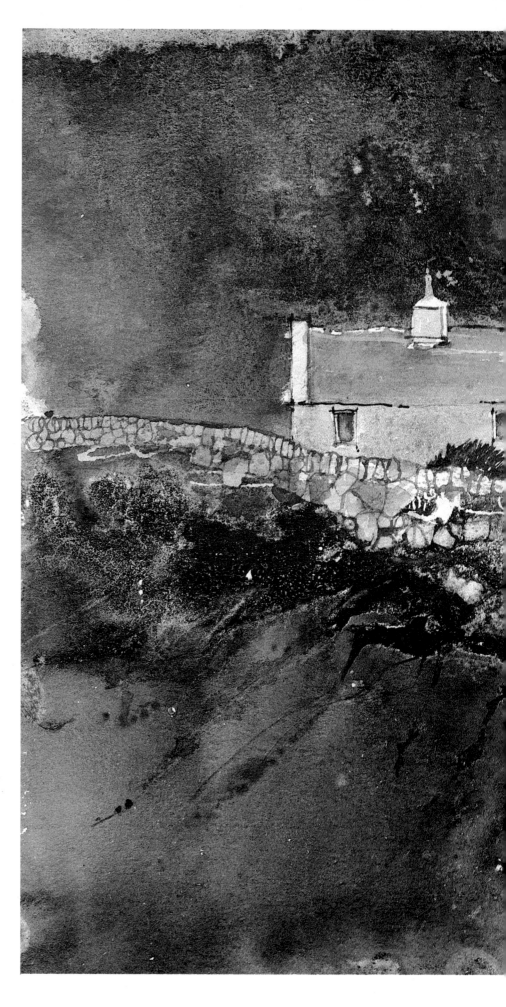

FARM COTTAGE, WALES, 7" x 10"
(180 x 254 mm)

The cottage and the lane that led to it made a strong right-angle, which I emphasized by surrounding them with dark tones. I also painted organic patterns in the foreground and added subtle textures in the background and foreground to soften the rectangular composition and contrast with the linearity of the main elements.

I established the warmth of the composition by brushing diluted cadmium red over the entire foreground, then I painted the cottage with Paynes gray, plus a touch of cadmium red and Hookers green on the roof. (In reality, the roof was a strong slate blue, but I understated it so the entire cottage would stand out against the dark background.) I kept the background simple, with a hint of speckled texture of Hookers green and India ink. I deliberately darkened the background to give maximum contrast to the cottage and lane.

SUGGESTED PROJECT
Create a painting where the center of interest is in the dark passages rather than the usual light areas. How can you direct attention to these dark areas?

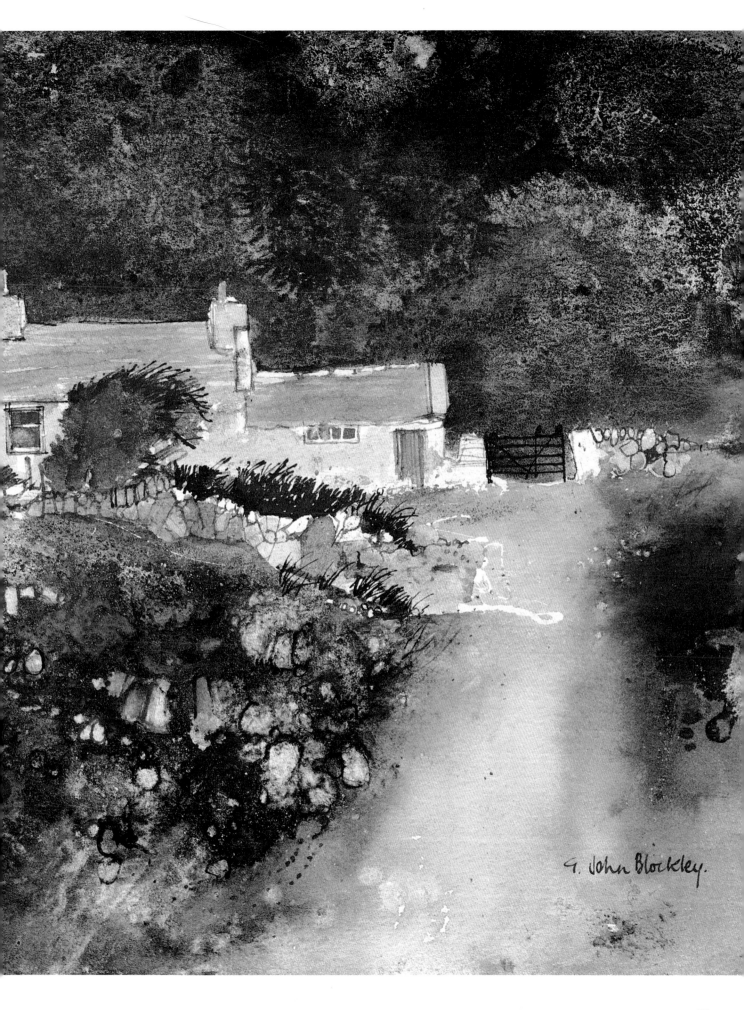

G. John Blockley.

I directed the ink into different formations that suggested the changing moods and textures of the mountain by depositing it in varying strengths on the paper and by varying the wetness of the paper and changing its slant. In some places the ink dried in large pieces because I held the paper almost still; in others, the ink separated into fine particles because I rocked the paper gently as it dried. I even pressed my thumb into the damp paint for additional texture. The starburst on the left was made with the end of a brush handle, dipped in ink and touched into the center of a circular float of water; the ink flared to the edge of the water in an unpredictable way.

Balancing forms and patterns

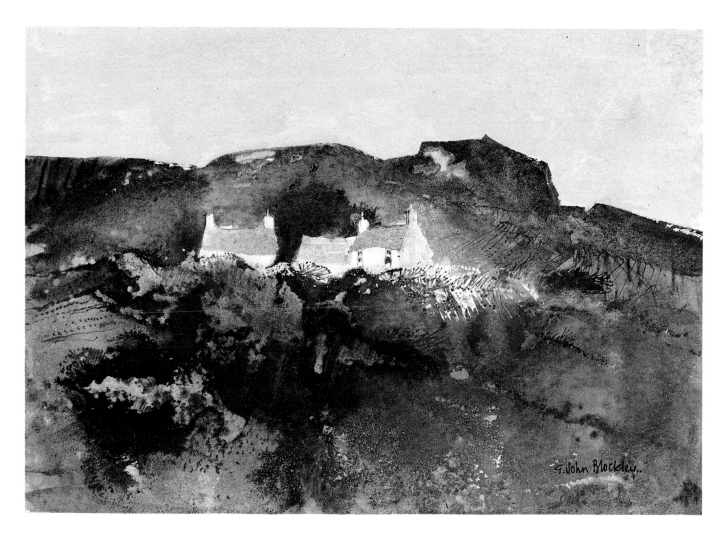

PEMBROKESHIRE COTTAGES, *8½" x 9" (215 x 230 mm)*

These cottages were neighbors to those shown opposite and I treated them similarly. The important ingredients of this landscape are the chunky cottages, the hard-edged linear outlines of the hills, and the elaborate pattern made by the foreground bushes. These are essential characteristics of this part of the country and so the painting is limited to them. You can't paint everything that you see in the landscape!

The hills echo the slopes of the cottage roofs, and all the hard edges are localized and set high in the painting, leaving a large area for the undefined blotched (India-ink technique) pattern of the foreground. This area of large foreground is literally correct in that it shows the sloping ground climbing up to the cottages, but perhaps more importantly, it provides a sufficient mass of indefinite forms to balance the precise forms above.

SUGGESTED PROJECT
Find an area of the landscape that inspires you and sketch it, incorporating into that quick sketch the strongest aspects of the scene. Then transform it into a finished painting after leaving the scene.

Adding interest to a dark foreground

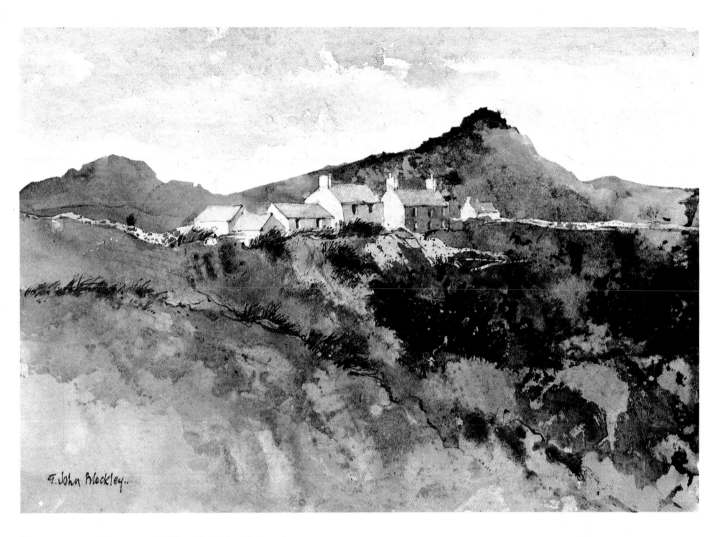

PEMBROKESHIRE COTTAGES, 8½" x 9" (215 x 230 mm)

The vitality of this abstract foreground—suggestive of rough plant growth against rocks—makes the simply painted cottages seem withdrawn in contrast. The sky above the hard mountaintop is flat in contrast to the green and black combination of the mountains.

After making the cottages and lightly penciling in the skyline, I brushed in a wash of cadmium red, subdued with a touch of yesterday's paint, and mingled it with a similarly subdued wash of Hookers green. Then I flicked some pen lines from the wet wash to suggest bushes. Rubbing the masking fluid away, I suggested roofs with a sideways stroke of a flat brush. As a foil to the foreground, the sky is an even wash of diluted white gouache tinted with a touch of Hookers green. I like to introduce flat areas of slightly opaque color like this because it contrasts well with the transparent color elsewhere. I have also tried to bring out the black and green abstract foreground seen against a simple, flat sky.

SUGGEST PROJECT
Find an area of the landscape that contains strong changes of tone. See if you can arrange it as flat areas of a single tone, against more decorative areas of a contrasting value. Make some edges hard and others soft. Try to achieve a balance that satisfies the eye.

Harmonizing contrasting shapes and textures

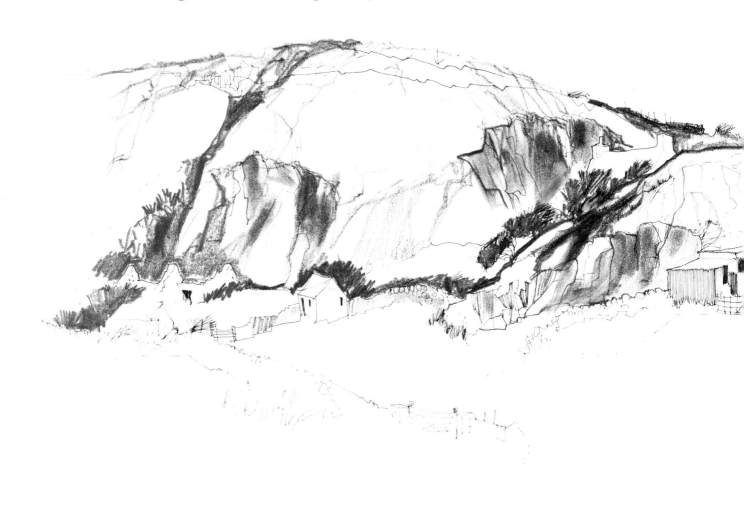

ABOVE THE MARSH, *19" x 30" (485 x 762 mm)*

In this painting, I was concerned with contrasting textures: rough granite boulders and stones, smooth rock faces, and the wet-into-wet treatment of the water. I was also attracted by the white shape of the farmhouse in contrast with the dark, textured ground. I particularly liked the dark peaty soil on the right; its somber pewter color contrasted with the silvery rocks behind it. The soil was grooved and channeled where rain had run down from the rocks behind—I washed burnt umber and Paynes gray over the paper for this pewter color. I also dipped a stick into watercolor to obtain the effect of soft, broken lines twisting into the contour of the land.

The rounded hills made generous scallops that played against the horizontal base of the water. When I painted the subject, I emphasized the plateaus on the right with a flat-topped outline; however, I lost the shapes of other buildings among the rocks—for example, the house behind the brown sheds in the center of the painting.

SUGGESTED PROJECT
Paint a landscape in which disciplined geometrical forms are integrated with freely expressed organic surroundings. Or tame the confused tangle of vegetation in a garden. Can you create a studied rhythm out of a chaotic scene?

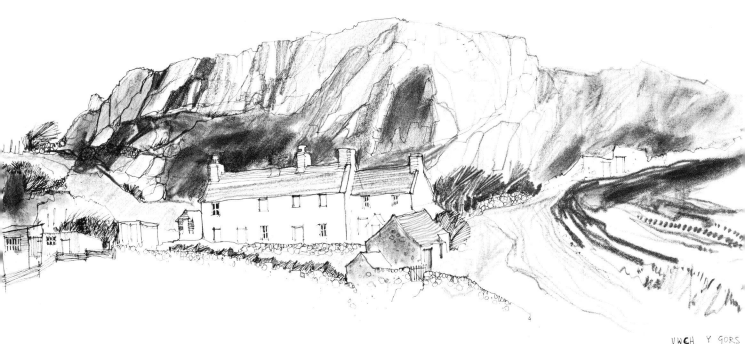

UWCH Y GORS

I liked the thin, veinlike lines on the smooth, upper surfaces of the rock that reflected the light sky and contrasted with the darker fragmented surfaces elsewhere in the scene. In the drawing, I used a fine-pointed, felt-tipped pen to draw the thin lines, and a thick stick of carbon pencil which I smudged into the paper with a wet finger for the dark passages. I felt a sort of rebellious excitement as I licked my finger and stabbed it into the soft black carbon areas. The thin pen lines, in comparison, had a more nervous quality. As my eye traversed the span of the farm, I decided to register its entire breadth across the double pages of a large sketchbook (though I later had to squeeze my painting into the width of a standard sheet of watercolor paper).

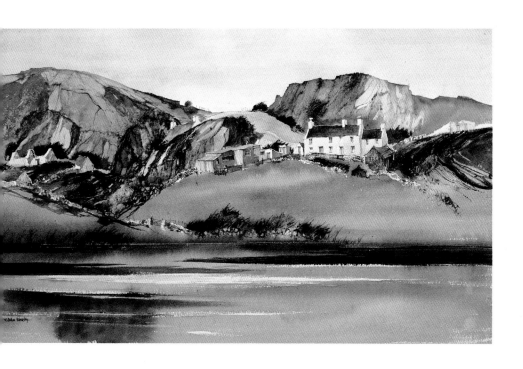

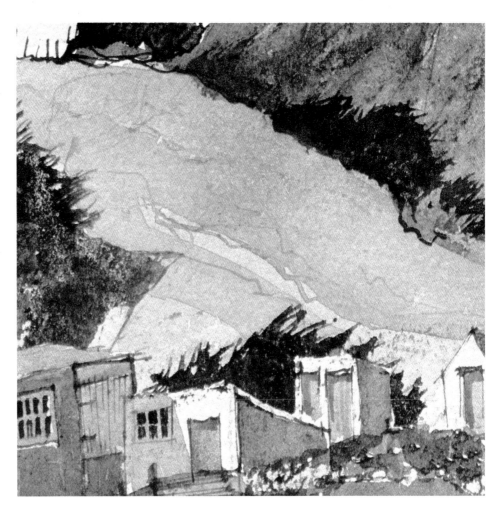

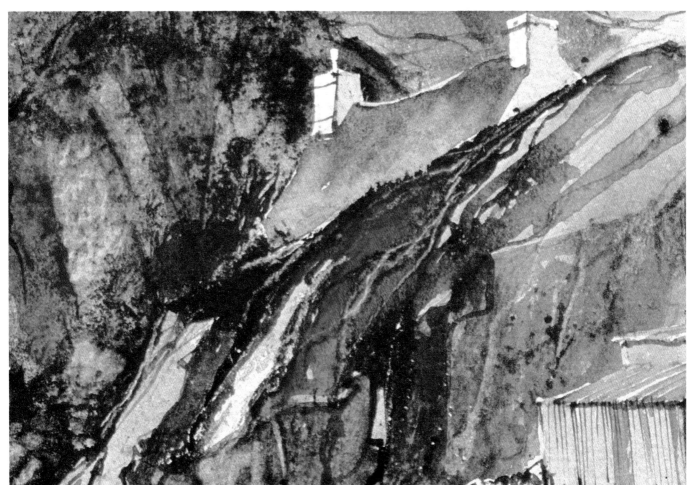

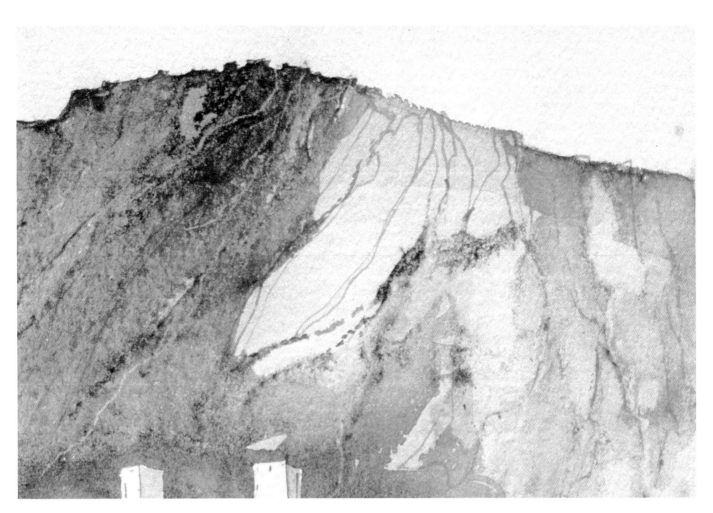

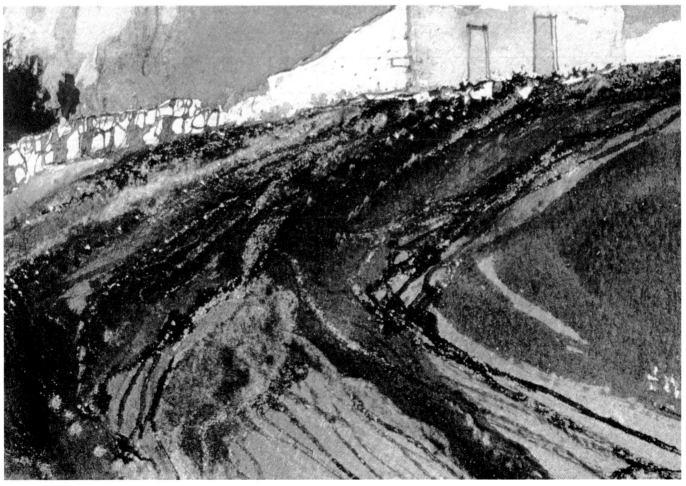

COASTAL FARMS

My fondest memories of the sea are of its quiet moods, with farms sitting along the coast. I like flat coastal landscapes, estuaries, and inlets, especially at low tide when the beach is still wet and it is difficult to distinguish between water and land. The colors of the mud flats are muted browns and seaweed greens, and sometimes they reflect the sky. The unpolluted air over the sea can transmit a beautifully pearly light. Sometimes you will see this light immediately above the horizon, its clarity emphasized by the cloud drifts above. At other times, however, the sky is more evenly colored and gradates only slightly from its great dome overhead to the horizon.

In the early morning, the lighting produces a soft, hazy sense of distance, with few substantial or solid features. Under those conditions, you must search for and carefully judge the tones, then paint the subtleties with sensitive brushwork. When painting coastal landscapes, an ill-judged tone will be instantly recognized, whereas in an aggressively painted mountain scene, such a mistake might escape notice.

Estuaries are usually pictured as vast expanses of sky and low landscapes. I confess

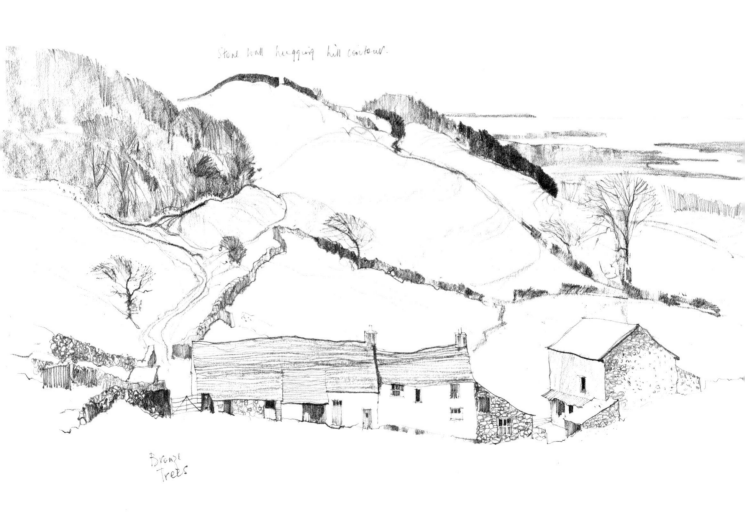

Stone wall hugging hill contour.

Bronze Trees

that painting big cumulus cloud formations, beautiful though they may be, does not attract me. I prefer to understate the sky by flowing simple washes over the paper and by suggesting cloud shapes with only a few hard-edged brushstrokes. This conveys a sense of space and makes the foreground seem busier by contrast. A simple sky also emphasizes the darker values and sharper edges of the buildings, which again increases the feeling of spatial recession.

When painting coastal farms, it is particularly important to resolve the amount of space you will allot them in the composition in order to create the feeling of large vistas and deep space. The big skies overhead and the soft, shimmering light reflected by the nearby water must also be kept in mind. I find that I am more interested in those qualities than in the aggressive moods of the sea. I do enjoy looking at rough seas, rocks, and towering cliffs, but for a painting, I most often turn to the quieter, subtle qualities that are special to the coast.

Bright light on
water

Near Ulverston
Cumbria February
Looking towards
Estuary –
Drawn sitting in
Car – windscreen wipers
going. Snow storm Cold.

Painting bright water reflections under a threatening sky

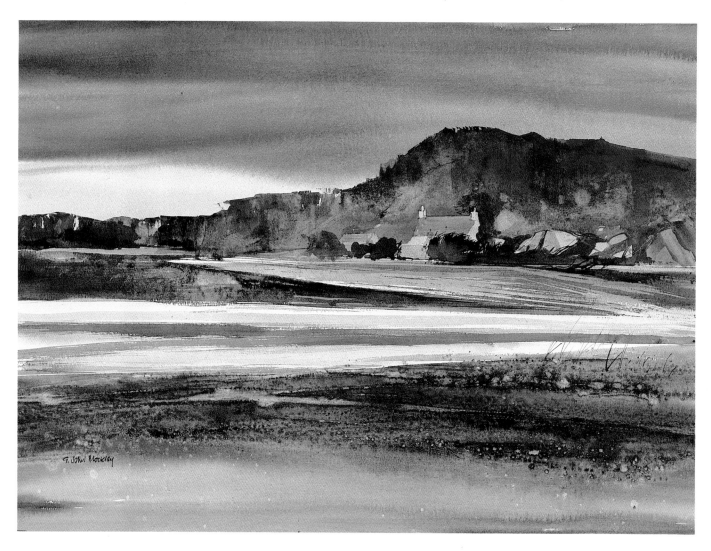

ERBUSAIG—WEST COAST OF SCOTLAND, 15" x 22' (380 x 560 mm)

In rain-threatening conditions, or after a rainstorm, the ocean sometimes reflects an exaggerated light. At such times, the sharp-edged land is gently accompanied by a gentle, brooding sky with a soft light pushing up over the horizon above a muddy, seaweed-tinted coast.

From the beginning, I planned the strong light on the strip of land and water to be the center of interest in this painting, I kept the lightest tones there by masking the strip first before painting the sky and foreground wet-into-wet. Later on dry paper I painted the strip of land with long, horizontal strokes of diluted colors that reflected the surrounding scene—the red, blues, and browns of the mountains and earth, and the gray and pearly yellow of the sky. Since I aimed for a somber but contemplative mood, I thus selected interesting, but not intense, colors. The soft, enveloping sky and strong horizontals express a tranquil mood, while the hard-edged, drybrushed mountains and highlighted land have a more active quality.

I often use the device of starting a movement away from one point of interest and then with a sharply pointed turn, bring the movement back toward the interest. Here, the middleground strip of water tapers and points the eye toward the right of the painting. Then the light strip of land behind it reverses the direction and points toward the soft light in the sky. The clouds and bushes also suggest a zigzagging movement. The hard edge of the water and the abrupt reversal are designed to force attention and jerk the eye toward the contrasting softness of the sky.

SUGGESTED PROJECT
Paint a landscape that contains a zigzagging movement like the one here. Use hard edges and abrupt tonal contrasts and changes of direction to create tension.

When clouds are low over the coast and heavy with rain, the light at the horizon is often intense and pearl-colored. Here, the softness of the sky is emphasized by the crisp, boldly painted mountains. I painted the sky wet-into-wet, but I painted the mountains after the paper was dry, which allowed me to reproduce their hard edges. In this painting, the light of the sky complements the brighter light on the land below.

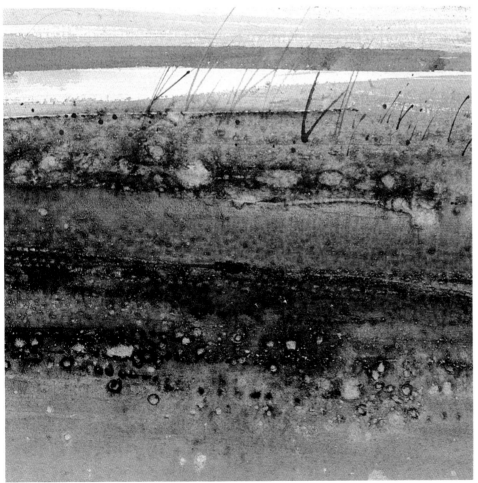

Texture gives an area its special character, while also supporting the general mood of the painting. Here, the textures in the foreground are mostly soft and blended, and the colors are muted. I painted the mud wet-into-wet with horizontal strokes, using a mixture of phthalo blue and burnt umber to give a hint of dank sea-weed. To suggest the moist, crumbled earth, I stippled the wet wash in parts with thick paint from the handle of a brush. I blotted out small, soft-edged shapes to suggest stones and used a pen to draw a few sharp-edged weeds sticking up. The weeds provide some vertical movement and direct the eye to the water above. I kept the foreground textures secondary to the main interest of the painting by letting the forms there blend gently together.

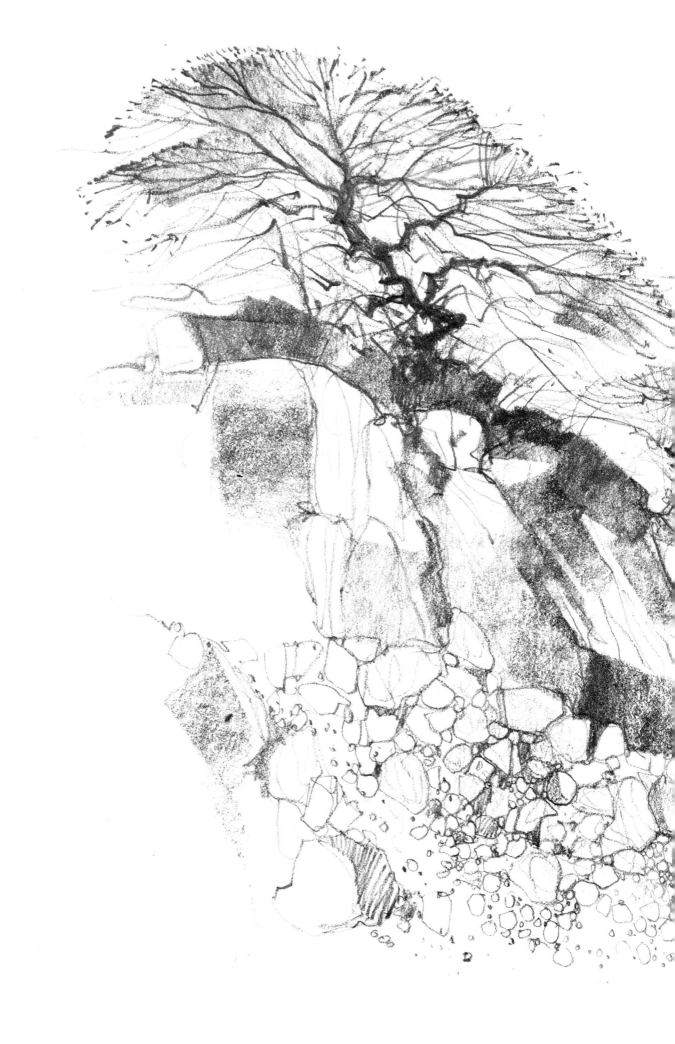

I was attracted by the almost stylized formation of the tree profiles and the massed shapes of the foreground stones. I liked the gnarled and twisted tree branches against the broad slabs of dark on the rocky bank that seemed to continue the slope of the tree trunks. I also enjoyed the contrast between the broad diagonal strokes, made with the side of a graphite stick, and the stones, drawn with the pointed end of the pencil.

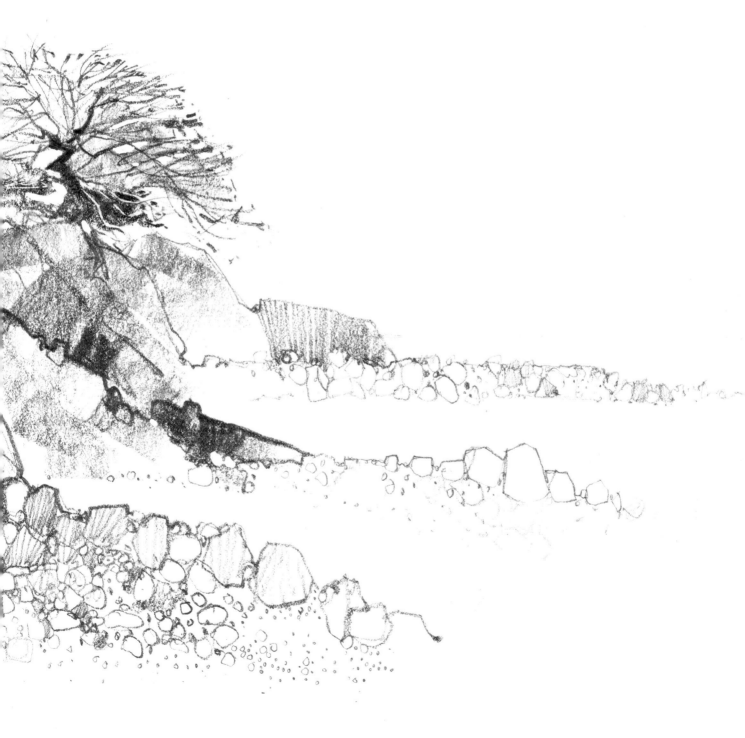

Handling a subtle sky

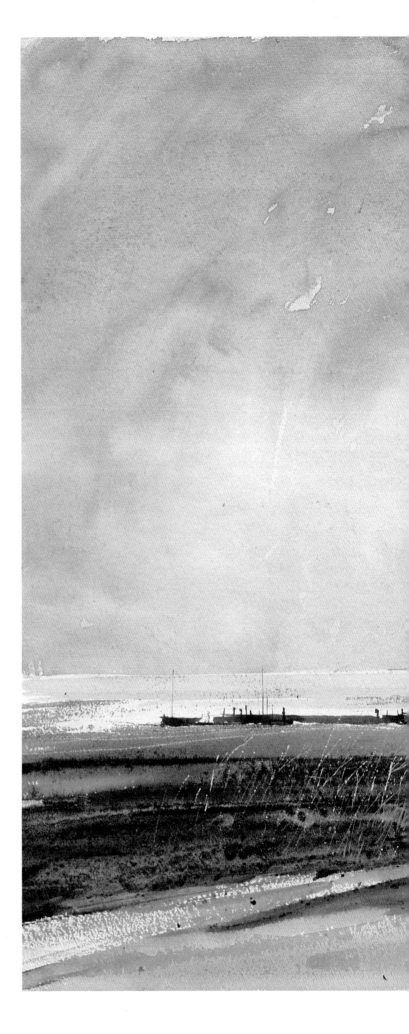

FARM ON MUD FLATS, *15" x 20" (380 x 510 mm)*

The sky is the dominant feature of this painting—its gentle forms and warmth established the character of the scene. I kept the horizon low to give a sense of vast space. Since the sky forms such a large portion of the picture, I had to concentrate on keeping it interesting by varying my painting techniques. For a soft texture, like that of the clouds, I used a traditional wet-into-wet technique, but I left a few sharp edges to provide a focus.

I painted the sky and most of the immediate foreground with yellow ochre subdued with a hint of Paynes gray. Then I added a little burnt umber to give the sky some earthly warmth. I also added hints of other colors to attract interest and suggest refracted light. I painted the farm buildings quickly and sketchily with crisp edges so they would stand out against the soft treatment elsewhere. For the dark tones of the shore and buildings, I mixed burnt umber and Paynes gray. To give movement to the scene, I drew dark lines across the foreground mud, indicating furrows.

The detail and bright colors in the immediate foreground heighten the feeling of deep space, and the strip of pale cobalt blue water provides a foil to the browns and grays of the landscape. The reeds are tall compared to the farm buildings; their relative size and angle reveal the distance from the foreground to the shore. The wispy, curving diagonals of the reeds also relieve the severity of the horizontals in the scene. I painted the reeds with Chinese white, made into a cream color with a little yellow ochre. I used that warm, delicate color to connect all the areas of the composition and harmonize the scene.

SUGGESTED PROJECT

Try to create a rhythmic pattern of shapes and tones in your painting. Here, for example, the distant sea repeats the light tone of the pool of water in the foreground. These light tones enclose and define the strip of mud flat and other soft-edged, dark tones that zigzag toward the buildings, creating a shape within a shape.

Try painting a flat landscape near your house. How can you make it interesting? Then look at some seventeenth-century Flemish and Dutch landscapes. How did these artists solve the problem of making flat coastal land interesting?

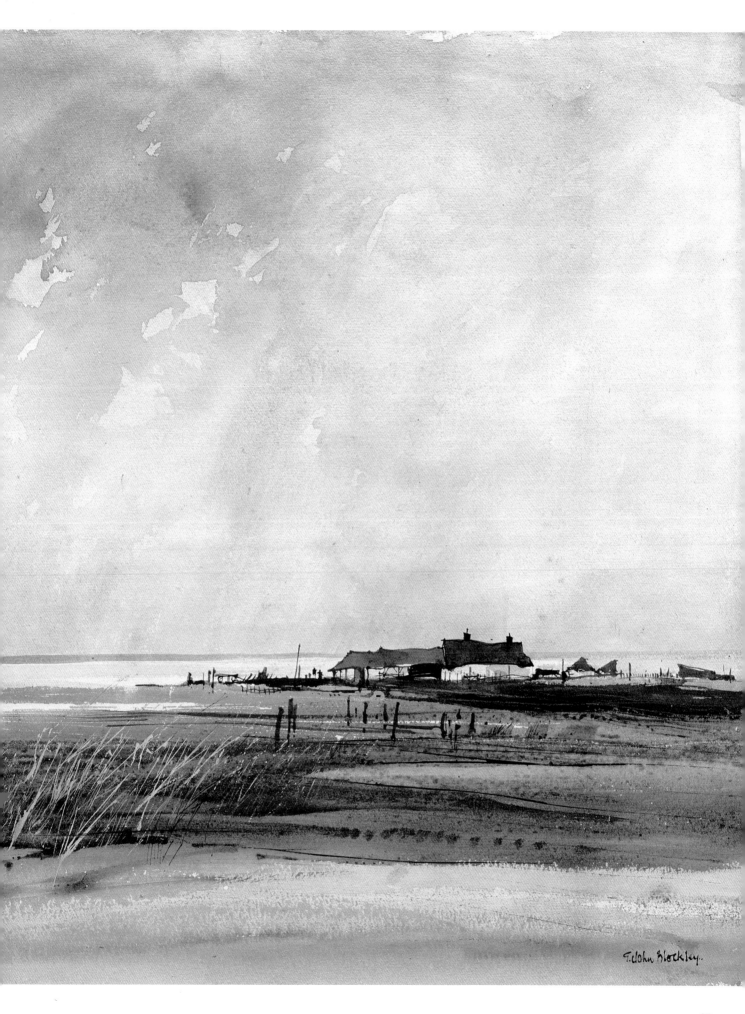

T. John Blockley.

Painting a light sky and a heavy land mass

COASTAL TEXTURES, 5½″ x 12″ (140 x 310 mm)

In this scene I was interested in contrasting the textured, abstract qualities of the land with the light sky. The raw, abrasive foreground and the finely granulated hills behind the cottages provided me with an opportunity to experiment with my paints. To help concentrate my interest on these textures, I decided to use a minimum of colors. Basically, I used cadmium red for an initial wash and black India ink to produce the strong patterns over it. I also used a little cobalt blue.

When planning my approach to the painting, I distinguished three main elements that would each require a different textural treatment: the land, the hills, and the sky. With the help of masking fluid, I worked each of those three areas separately. Masking the sky and hills first, I washed cadmium red over the land area and poured black India ink into it straight from the bottle. Then I dried some ink patches along the bot-

tom with a hair dryer, keeping the middle distance wet by shielding it with my hand and dripping water from a brush into it and allowed rivulets of water to trickle into the drying ink. When I washed the wet ink away, the cadmium red was blotched with abstract shapes of black. Then I unmasked the hills and painted them, then the sky.

SUGGESTED PROJECT
Paint a strong scene by simplifying your subject into separate, identifiable areas of surface textures, and reduce it to only a few colors. This disciplined approach will reduce your subject to a few self-contained units and yet integrate them into a balanced whole. Seemingly clinical exercises such as this will develop self-discipline and confidence, and build up a vocabulary from which personal expression can evolve.

Painting a heavy sky and light-colored land

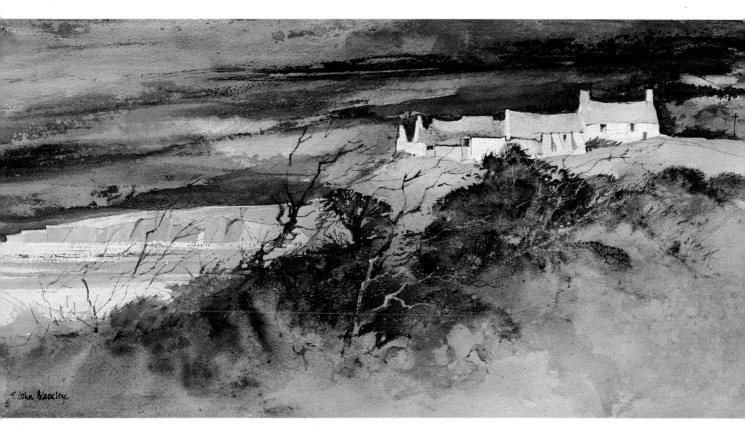

FARM ABOVE NEWGALE PEMBROKESHIRE, *9″ x 18″ (230 x 460 mm)*

This painting shows one of my favorite lighting conditions—when a dark sky seems to be contradicted by an intense light cast on parts of the landscape. This occurs only when the sun momentarily breaks through a pewter sky and its light falls on reflecting surfaces. These are rare moments, to be remembered for future paintings. On this occasion, the water achieved an almost phosphorescent look and the farm buildings were vividly white. I remembered a glint of green on the distant cliff.

After masking the buildings and cliffs, I attacked the sky with a 1″ (25 mm)-wide housepainter's brush and swept strokes from one side of the paper to the other. I jabbed the damp brush into undiluted paint on the palette—half of it into cobalt blue and the other half into Paynes gray to get two simultaneous streaks of color. Then I brushed the paint across the previously dampened sky. In places, the two colors fused together and then separated. It is satisfying to see how this crude, aggressive process can achieve effects that are both subtle and spontaneous.

To further develop the sky, I temporarily protected the lower half of the paper with a piece of cardboard, stood back a few paces, then flicked paint from the brush with a quick jerk of the wrist, so that droplets were literally thrown at the painting. When the sky was barely damp, I dragged black ink across it with a long-bristled oil painter's brush that was worn and splayed.

SUGGESTED PROJECT

Paint a stormy scene from memory—one that impressed you vividly. The details don't have to be accurate (this is not a test), but you must try to reproduce as accurately and strongly as possible the initial impact it had on you. What colors and value contrasts were there? Was the lighting unusual in any way? How can you express this in paint? Here, for example, the foreground was painted wet-into-wet in a traditional way, with soft sable brushes, while the sky was painted with a stiff house-painter's brush and a worn oil painter's bristle brush to obtain aggressive, abrasive surfaces.

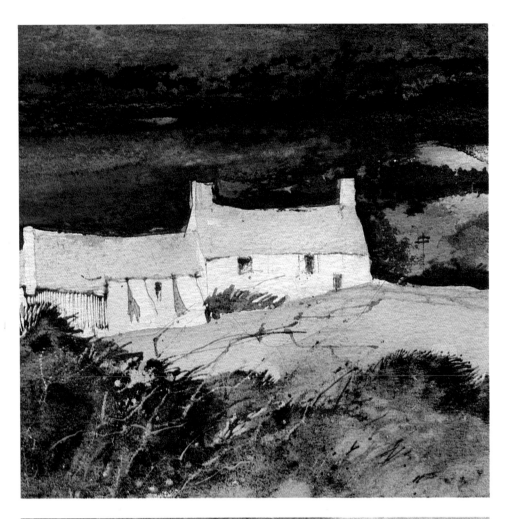

I left the cottages as white paper and only lightly tinted the roofs to express a feeling of reflected light. Actually, the roofs did have more interesting detail: those farm cottages are weatherproofed against Atlantic storms by a covering of thick cement slurry. The cement is applied over heavy wire cables that pass over the roof, tying the covering onto the building. However, I took the liberty to ignore this interesting detail because it would have broken up the form of the roof and reduced the impression of light.

I painted the foreground wet-into-wet with sable brushes to suggest some bushes and ground cover. I kept only the top edges hard, so that interest would be contained high in the painting, close to the buildings. Then I removed the masking fluid and painted the cliffs with close-valued tones, so they would remain in the distance.

Expressing distances through variations in values, texture, and edges

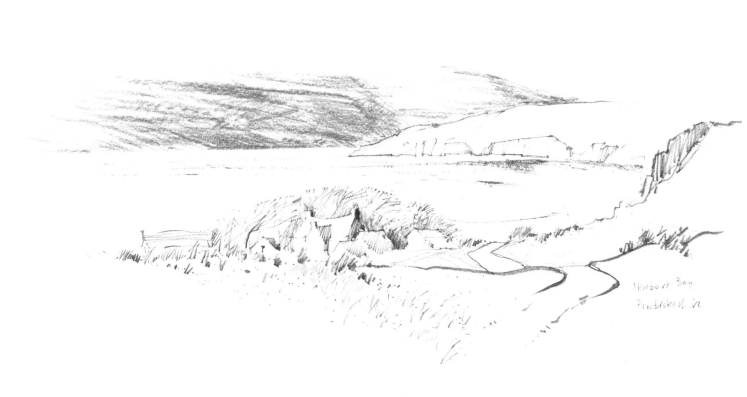

FARM ACROSS THE WATER, *17″ x 12″ (430 x 305 mm)*

This painting demonstrates how contrasts in texture and value can help create the illusion of distance. Here, the strip of land in the foreground seems more immediate, tangible, and in focus than the buildings and islands across the water because I have painted it with strong value changes, sharp edges, and heavily developed textures. On the other hand, since I have painted the background with lower values, less contrast, and softer edges, it seems far away and misted by the ocean atmosphere. Notice, however, that it is sharp contrast and not necessarily more accurate realism that makes the foreground appear closer. In fact, the foreground is actually handled more abstractly than the background; it only seems to contain precise detail because of its hard edges and rich texture.

The gravelly beach served as a departure point for my experimentation. Whenever I see such heavy textures, I am inspired to play with my painting tools and invent fresh techniques to express my enjoyment of these tactile and visual qualities. Here, I used a stiff brush on smooth paper for the white lines. Then I added dots of paint with the handle of the brush, indenting blobs of paint into the damp paper. Finally, I poured the ink and rocked the paper to get the fine grain.

SUGGESTED PROJECT
Paint a scene where the main interest is in the distance, giving a panoramic effect to the painting. Besides drawing these objects small because they are so far away, also try to express distance through variations in values, edges, and textures. Can you think of other ways?

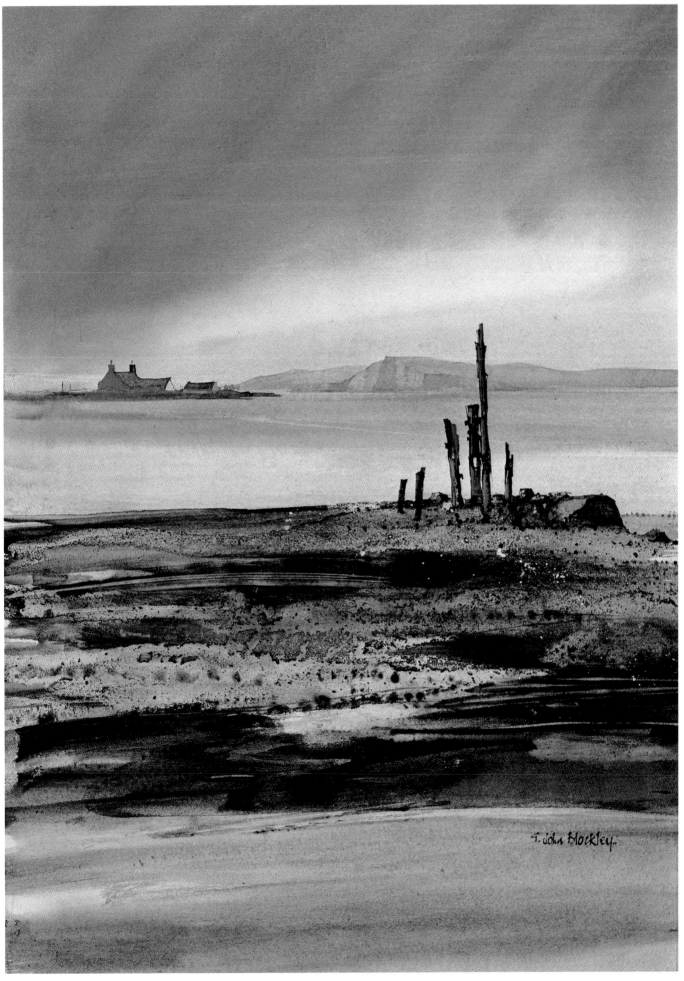

Painting the sky as the center of interest

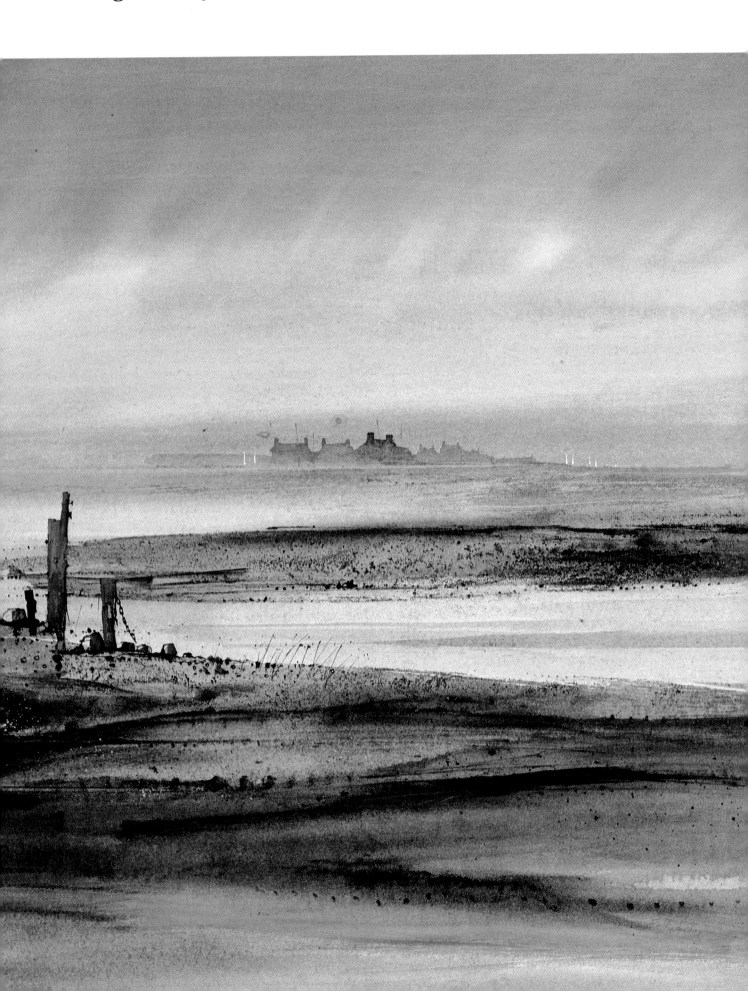

G. John Blockley.

COASTAL FARM, EARLY MORNING, *13½" x 18½" (343 x 470 mm)*

My main objective here was to capture the tranquility and subtle lighting I saw on the coast at dawn one day. The sea had retreated and the wet ground reflected the sky, shining a dull gray that was almost silver in places as mud became water and water became mud. The roofs of a distant farm were silhouetted against the sky, but the buildings' bases merged into the early morning mist. When I returned to the studio to paint, my only reference, besides my memory, was an outline of the rooftops on the back of an envelope—there wasn't anything else for me to draw!

I had a strong impression of the mud engraved with lines of silvery light, and I wanted to recreate that effect. So, I deliberately chose a smooth-surfaced watercolor paper and planned to use a 1" (25mm)-wide housepainter's brush (and Paynes gray and raw sienna) to paint the mud. I knew that the stiff bristles would slide across the hard, smooth surface and splay open slightly to leave narrow lines of paper barely visible. When planning the painting, I also remembered that the tide had left behind a strip of water, very light and crisp edged, that provided a positive statement within the overall softness of the scene, so I masked that shape from the start.

I also dotted paint into the wet foreground wash with the end of a brush handle to create tracks of soft-edged spots. Then I dampened the sky with clean water and gently brushed it with diagonal strokes to give the effect of light breaking over the horizon. When the paper was dry, I rubbed the masking fluid away and tinted the strip of water with a pale mixture of cadmium red and Paynes gray. I painted the farm buildings and posts in neutral tones because I wanted to keep them unobtrusive and secondary.

SUGGESTED PROJECT

Try painting two versions of the same subject, but base each one on a different concept, and vary the format of the painting, too. For example, the painting on page 101 was done on the same location as this one, but there the subject is the concentration of light at the horizon and in the sea. To draw attention to it, I have enclosed the area with darker tones and give it a prominent place, high in the painting. The crisp, dark cottages and the posts—in fact, all the darks—serve as a foil, to further intensify the light. On the other hand, the subject here is the diffused lighting, which has permitted the gentle tones of the mud banks to both emerge and disappear in various areas. There are many such examples in this book of paintings and drawings that are based on the same subject. Study them and see how I have varied my approach in each case.

MOORLAND FARMS

The moorland, with its heavily interlaced textures, bits of broken walls, long grasses, and gaunt trees, provides good foreground material. I especially like the profiles of its winter bushes that lean to one side, their edges precisely clipped by the wind. Near the farms, stone walls enclose green fields and make intriguing geometric patterns. Some fields taper almost to triangles; others are just long strips of green. The walls in the northern regions of England are built from hard, almost black stone—they look like dark bands over the green fields. Farther south, in limestone country, the walls are white and appear as bleached skeletal networks running over the terrain. The grainy textures of the moors are rugged but not as austere as those of the mountains. The low sweeps of land can carry you away, and the farm buildings can become lost specks in their undulations.

In some areas, the moorland is bleak, having only rough grass and heath. But I have seen the early evening light transform that coarse landscape into swirls of extravagant color—bands of ultramarine, unbelievable blue, streaked with bronze and bright ochre. It is then that the land, with little foliage and few trees, becomes a playing field for abstract expressionism.

In winter, other transformations occur. Snow turns the harsh landcape into a showcase of smoothly sculptured profiles, and the bare skyline becomes a graceful curve. The close-

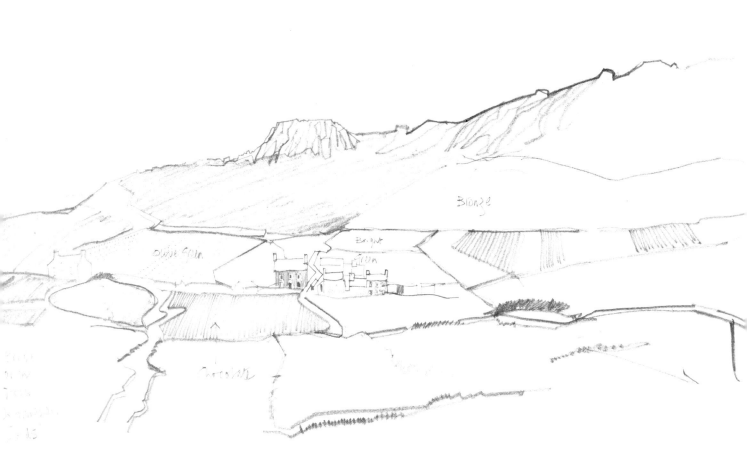

up features are also exciting to paint. Just imagine, for example, the shapes, colors, and textures of a large black rock breaking through the fresh surface.

Most moorland farms have features characteristic of the region. The walls are built of rock, some in large slabs and some in thin wedges, and the roofs are made with thick slate. The color of the buildings varies according to the local stone: in some areas, they are a severe blue-gray or green-gray; in other places, their limestone surfaces glint almost silver in the sunshine. Frequently, the house and farm buildings are joined together under one roof. They are called "longhouses"; people live at one end and cattle in the other. Usually the farms are protected by sycamore trees, appearing in scattered groups that seem to accentuate the loneliness of the moor.

The main impression a moorland gives is of mountainlike textures intermingled with subtle curves and rolling contours. The orderly, patchwork fields surrounding the farmsteads contrast with the wilder, uncultivated lands. The predominant colors are muted umbers and greens, with some warm grays and oyster pinks. There is a cool, bluish lighting and a thin atmosphere; the skies are mostly clear, with sheets of thin clouds, if any. You will find the painting there invigorating, the type that calls for decisive action.

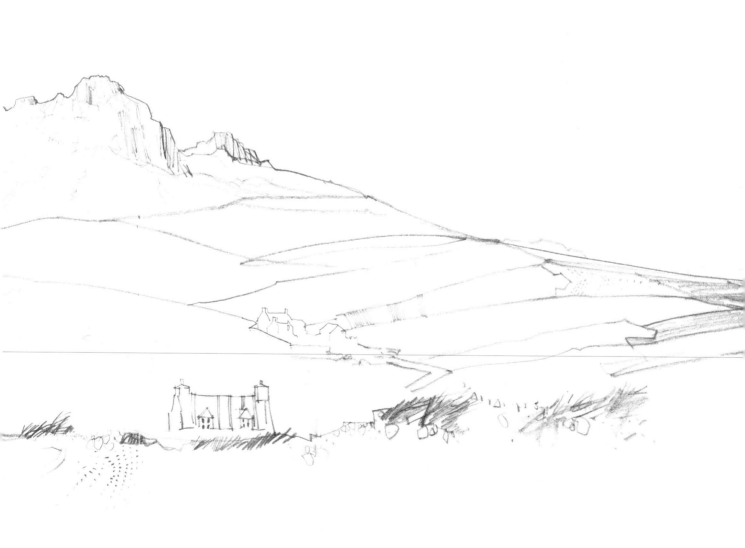

Emphasizing an area of interest

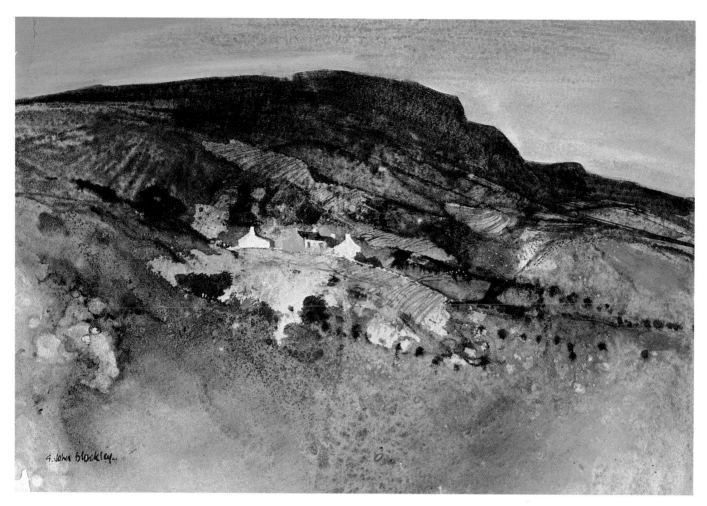

PEMBROKESHIRE POTATO FIELDS, *10" x 14" (255 x 360mm)*

This painting shows how somber color can be used to emphasize brighter color. The cadmium red ground on the lower slopes of the hillside (which were plowed for growing potatoes) was my main interest. To make it appear even brighter, I placed it between the bright green of the foreground and the somber gray of the hill beyond. I also kept the sky a middle-value tone, so that the pink would be the lightest color and attract your attention immediately. I further distinguished that area by drawing the lines of the plowed fields spiraling up the hill contour, using a pen dipped in watercolor. The crisp lines stand out clearly on the light-colored fields; they contrast with the soft-edged surrounding areas and thus again emphasize the pink field. The lines also provide graphic interest and lead the eye into the distance. This simple strategy of containing the brightest, lightest tones and the most precise drawing in one part of the painting to call attention to it was completely planned in my mind before I started to paint.

I painted the outer fields wet-into-wet to give them gradual tonal changes, and I dotted paint into the wet wash to create fuzzy, slightly mottled effects. Upon closer examination, these fields lose their identity and become abstract expressions of my response to the land.

SUGGESTED PROJECT
Select one aspect of a subject and relate all other areas to it. Also, strengthen your principal area of interest with a few specific features—buildings, trees, a hard-edged skyline—and leave large areas of comparative emptiness elsewhere to focus attention on the main features.

I used wet-into-wet washes in transparent layers to build up this secondary, soft, moody area. I originally drew a structure of dark lines in the upper field, but then subdued it with an overlay of cadmium red. The bits of dark sediment resulting from my waterproof-ink technique add surface texture to the soft green ground. The linear movements here are gentle and lethargic: generous curves, slow undulations, and veiled lines spreading outward.

Over an initial wash of warm pink, I blended layers of rich colors, letting the pink show through. Then, while the paper was still wet, I used the end of my brush handle to draw the heavy, dark lines and soft dots. To get the light red veinlike streaks in the gold area, I brushed water over the paper, then drew watercolor into the surface of the water with a pen. I also tilted my paper to force some of the paint to spread downward for an organic effect. The many different lines give movement and energy to this area.

Soft spots of light in amorphous shapes give a dreamy character to the foreground. I created these spots by blotting the area with repeated touches of a rag wrapped around my finger. To get harder edges, I let the wash underneath dry before laying on the next one and blended the soft edges while the washes were wet. As a delicate accent, I loosely drew lines around the small circular shapes with a fine brush.

Using contrast in color
and edges for interest

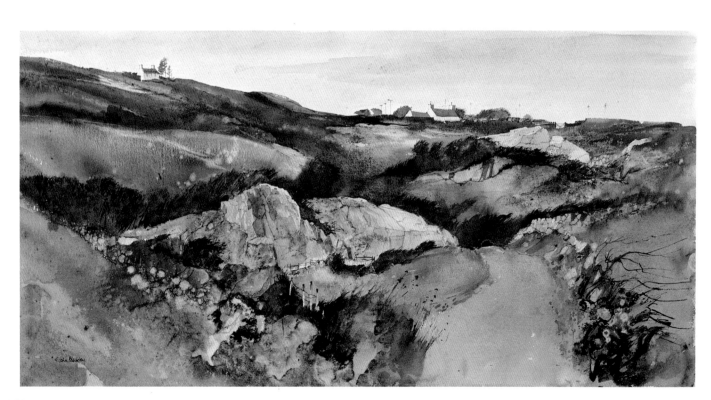

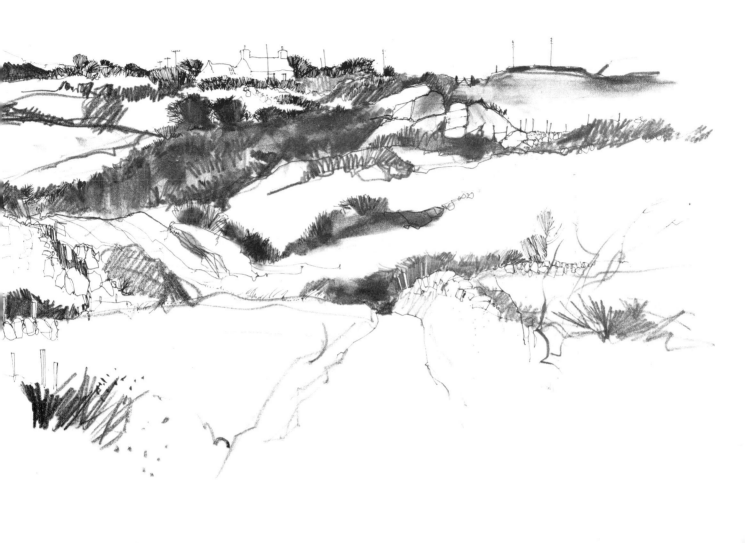

MOORLAND GORSE, *16" x 28" (405 x 712mm)*

The painting is concerned with the mood of this particular landscape. The dark green gorse, itself prickly and abrasive, creates a feeling of restless movement, and its continuous rhythms, which follow the contours of the land, hold the painting together. Within the apparently indiscriminate content of the painting there are a few, carefully planned anchor points. The large foreground rock is echoed by the shape of the distant rock—together they suggest a spiral route from the foreground to the distant cottages. Even so, the balance of the painting is unsatisfactory because the comparatively empty extreme left-hand side contributes nothing to the composition. Therefore, before exhibiting the painting, I cut the left-hand side away to the small skyline cottage. Even though this lost some interesting foreground texture and the expanse of the original sketch, it did achieve a better balance. The cropping also forced the road a little further into the painting for improved distribution of interest on both sides.

SUGGESTED PROJECT
Add sparkle to a scene that seems dull by emphasizing contrasts in edges, colors, or shapes. Contrast—and conflict—sparks interest and creates a mood. Look for it in the scenes you paint.

I was especially concerned with contrasts in edges. The rocks are hard-edged, the ground contours merge softly together, the grass against the stone has a feathery outline, while the gorse bushes are sharp and spiky. I was also interested in color contrasts, with the warm pink bringing some excitement to the cool greens and blues.

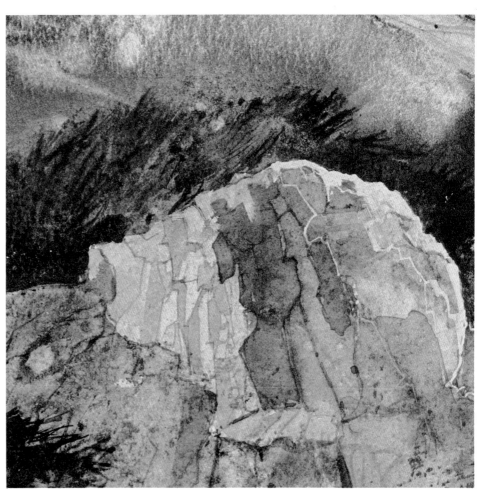

I obtained the hard-edged details of fence and rocks by masking them before brushing in the landscape colors. I spontaneously swept in the color washes for the ground, and when the paper dried I drew the gorse branches with a pen dipped in watercolor.

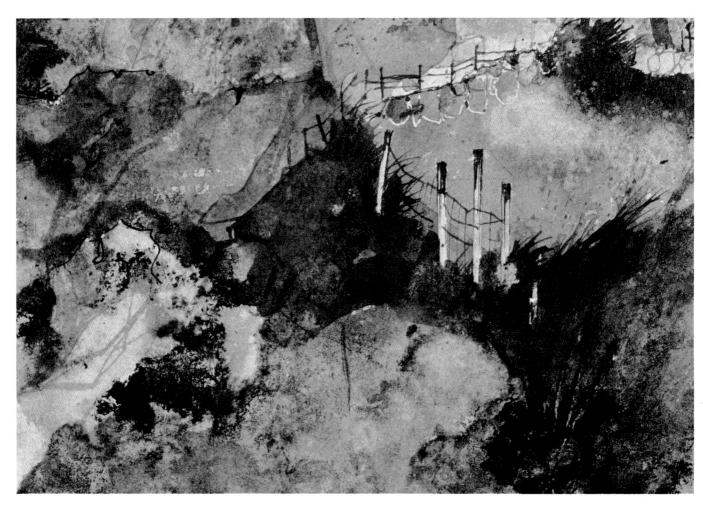

I lightly indicated houses at the top and added other small details to the skyline, such as the gate and telephone poles. These details add realism to the scene and help identify the lower portion of the painting as a moorland landscape.

Contrast always sparks interest. In painting, it is important to think of how different qualities interrelate and how you can use the conflict to create a mood. I used a mixture of treatments here, from the detailed drawing of rocks and fenceposts to the broad, free-flowing color washes of the land.

Creating an abstraction through color and brushstrokes

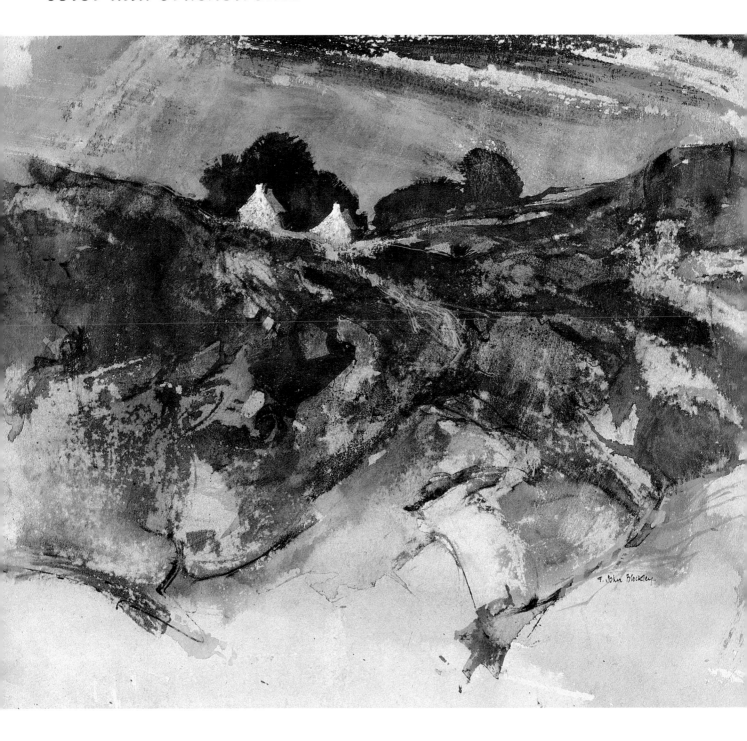

PEMBROKESHIRE HILLSIDE, *11½″ x 13″ (292 x 330 mm)*

Although it contains cottages and trees, this painting was done in the abstract spirit of
the previous painting, though in a more spontaneous and perhaps flamboyant man-
ner. The motivation here was to work vigorously. The brushstrokes were continuous,
and I instinctively changed them to produce swirling movements, vigorous drawing,
and blotched surfaces. The colors here are rich and the painting tempo vigorous, com-
pared to the quieter drybrushed, scumbled handling of the previous work. I wanted to
show a kind of explosion of energy as a change from the quiet buildup of the other. To
do this, I used vigorous brush movements to give a rough quality to the paint surface,
and I used coarse tools—a stiff hog-bristle brush and a 1″ (25 mm)-wide house-
painter's brush. I let my hair down on this one—almost threw the paint at the paper,
not stopping from start to finish. I think it conveys a sense of the moorland pattern
better, perhaps, than a carefully considered and executed work.

First, I made a few curved brush lines with the bristle brush as a sort of skeletal
basis for the work. Then I brushed wet watercolor over the paper, in random direc-
tions, with the housepainter's brush. I blotted parts of the paper with a rag and then
worked swirls of paint into the wet paper with a round brush. I left the bottom of the
paper almost white as a relief to the dark, churning movements above. When the
washes were dry, I overpainted parts of the sky with very dilute greenish gouache
worked in downward diagonal strokes to suggest light rays. The slightly milky paint
gives an interesting misty quality to the scene.

The tossed landscape is built up in layers of colors. First I brushed in Hookers
green, cadmium red, burnt umber, and Paynes gray freely onto the wet paper, letting
them blend together. For drama, I swirled thin washes of black ink over the first colors
while they were still damp. When the paper was dry, I painted the cottages with
gouache and emphasized them by placing dark trees behind them. Then I added
touches of white gouache in front of the cottages and used a pen to pull out fine lines,
making a trail down the bumpy terrain. The cottages provide the only solidity in the
scene. Together with the background tree shapes, they identify the abstract fore-
ground as a landscape.

SUGGESTED PROJECT
*Select a rather ordinary landscape, with no unusual features, and paint it with a riot of color and
brushstrokes. Don't worry about realistic details. Just plan your major colors and values so they
work together as a whole. The results may surprise you!*

ABANDONED BARNS
YORKSHIRE

Capturing the effect of snow

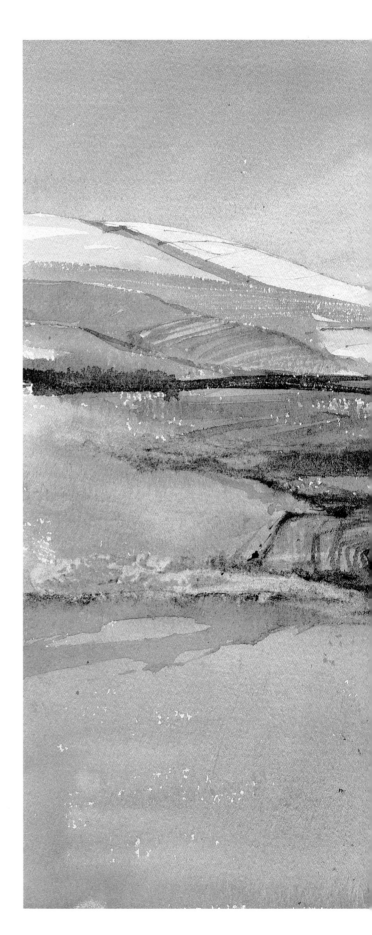

Moorland Snow, *11" x 15" (280 x 380 mm)*

The special fascination of a snow-covered landscape comes from the simplification of values. The landscape here is resolved into fairly defined divisions: the white snow, the cool blue shadow, a warm middle distance, and a neutral-colored foreground. The range of tonal values is also fairly well simplified: white snow, middle-value shadows, and dark trees. The smooth undulations of the snow's surface appear bright and crisp, and with such intensity and contrast that tonal variations and edges elsewhere are subdued and blend together. These observed values form the basis for the entire painting.

In terms of the composition, I planned a vertical zigzagging movement through the center of the landscape that continued in the cloud. This leads your eye through the picture and acts as a foil to the horizontal curves of the moorland. As always, I balanced hard edges against soft and warm colors against cool. The white paper also plays a special role in this painting. Instead of serving only as an accent or highlight, here it becomes a positive element, with body and texture. Before painting, I thought carefully of what I wanted to say about the landscape. Then, with a complete image in mind, I worked quickly, using broad washes to give the painting vigor, freshness, and a sense of open space.

I masked the snow-covered upper moor with film for a precise shape with a crisp, flowing curve for the skyline. Then I washed yellow ochre and cobalt blue from the top of the paper to the bottom. To obtain a warm middle ground as a foil to the cool snow, I brushed the middle ground with burnt umber slightly grayed with cobalt blue, working wet-into-wet. Then, with thicker paint, I stroked soft lines into the wet wash to suggest the contours of the ground. I blotted out the pale, soft-edged forms of the foreground and let the paper dry.

I peeled away the masking film and painted cool shadows across the snow, then indicated the trees and farmhouse with burnt umber. I deliberately made the trees hard-edged and curved to echo the sharp, curving skyline. To brighten the scene, I added soft accents of cobalt blue mixed with a little cadmium red, plus some yellow ochre to the snow area.

SUGGESTED PROJECT
Create a snow scene using only a few simple values and colors. Use the darks in the landscape for contrast and to direct the eye to your center of interest.

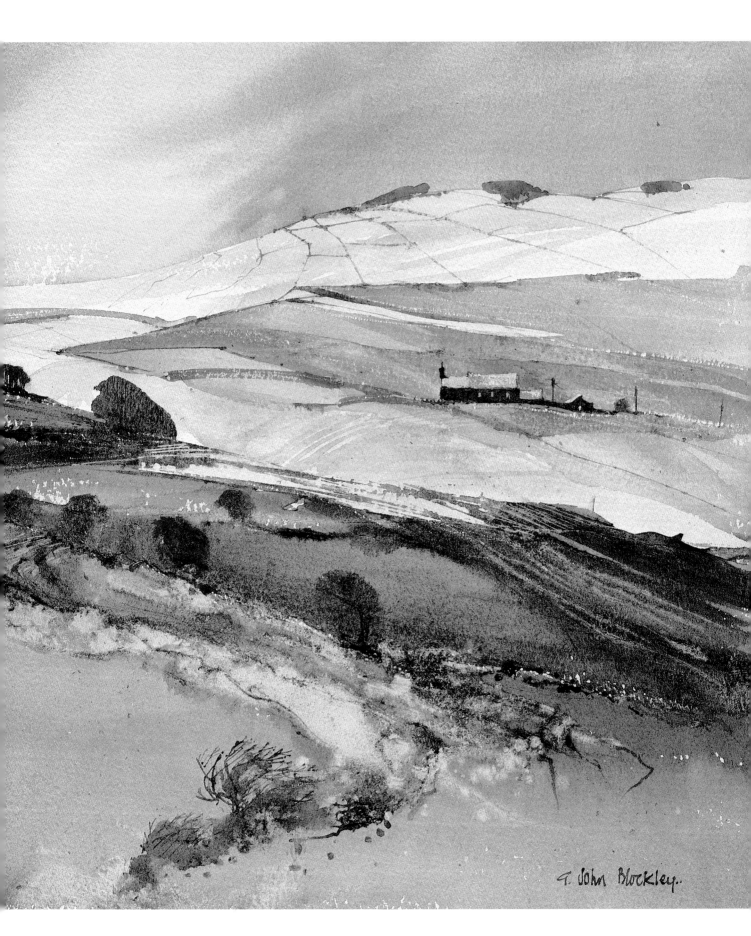

G. John Blockley.

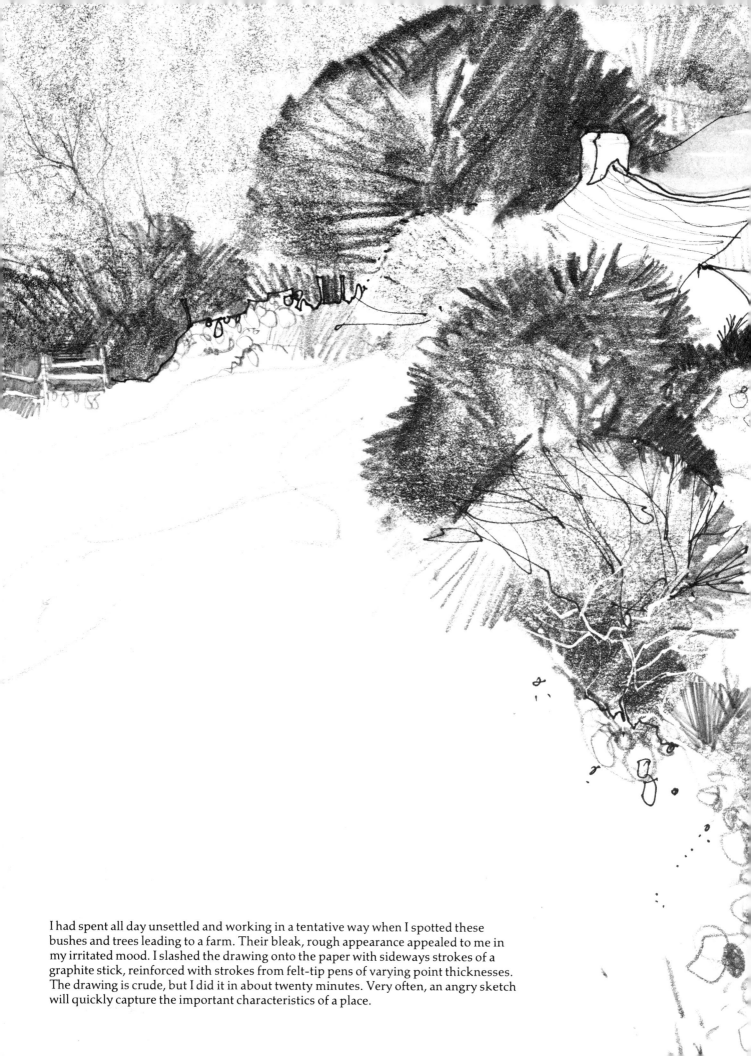

I had spent all day unsettled and working in a tentative way when I spotted these bushes and trees leading to a farm. Their bleak, rough appearance appealed to me in my irritated mood. I slashed the drawing onto the paper with sideways strokes of a graphite stick, reinforced with strokes from felt-tip pens of varying point thicknesses. The drawing is crude, but I did it in about twenty minutes. Very often, an angry sketch will quickly capture the important characteristics of a place.

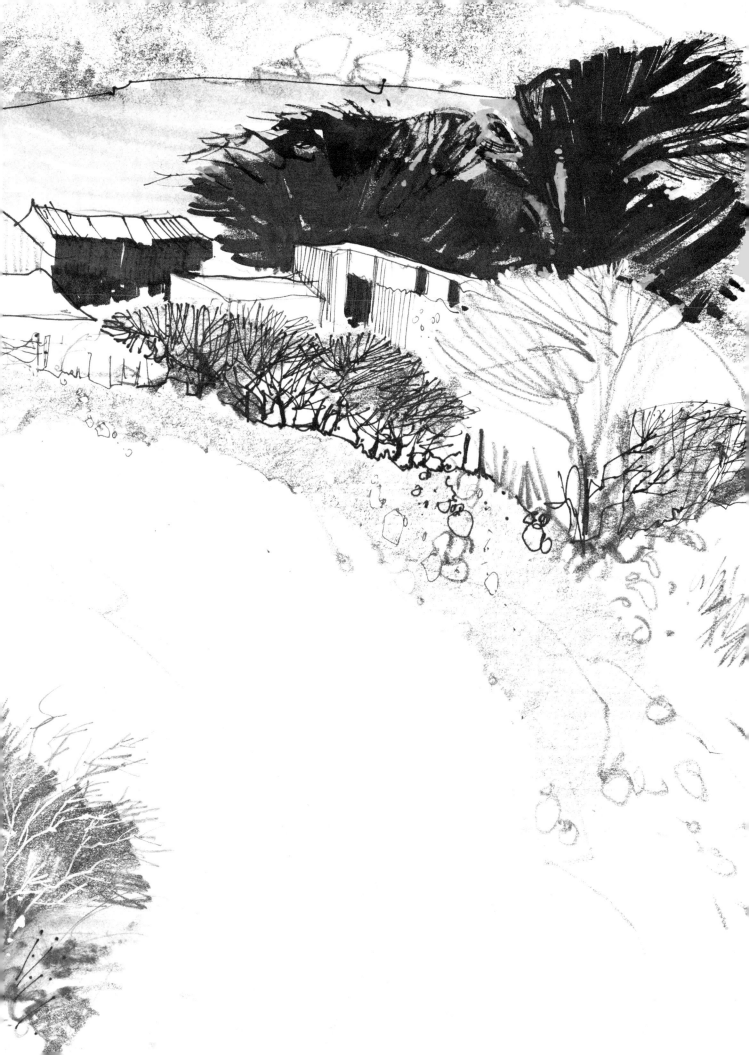

Expressing a realistic scene as an abstraction

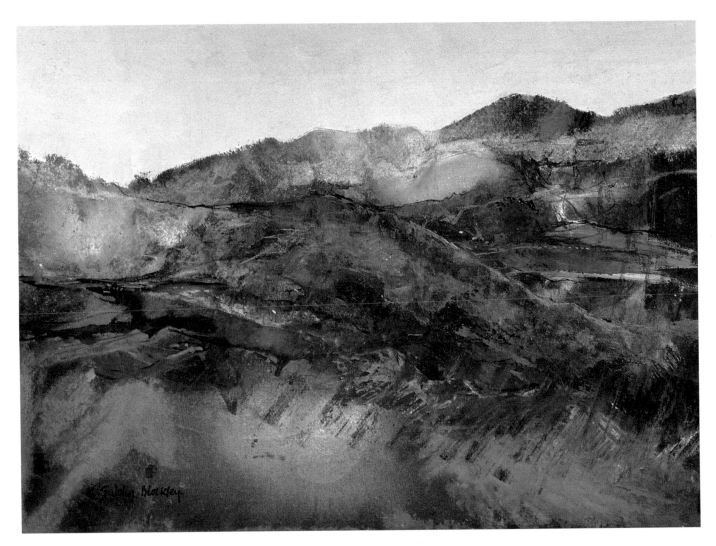

GRAY AND PINK MOUNTAINS, *8″ x 11¼″ (205 x 285 mm)*

This liberal, seemingly unstudied display of paint was my response to the subtle gray and red coloring of the mountains above the moors of North Wales. The painting is a very personal interpretation of the colors there and says more about the quality of the colors I saw than it does about the mountain itself. To obtain the chalky veils of color in the background as well as the crude, expressive passages in the foreground, I used gouache (watercolor with opaque white paint), applied with a worn-out old hog-bristle brush. Since I wanted to focus attention on the color nuances in the distant mountains, I suggested the foreground without much distracting detail.

I began the painting by floating burnt umber, raw umber, and Paynes gray into a wash of diluted cobalt blue. I let the colors merge on the wet paper, and when the wash dried, the surface was mostly dark with occasional hints of pale blue. I painted the sky flat and opaque using Chinese white gouache tinted with Hookers green and shaped it to describe the mountain profile. The flat texture emphasizes the delicacy of the mountain colors and its perforated, chalky surface. The soft edges in the foreground echo the background treatment, unifying the picture and moving the eye gently from background to foreground.

SUGGESTED PROJECT

Choose a landscape that suggests large areas that are nonfigurative in themselves but meaningful when related to some chosen factual area of interest. The painting here, for example, is concerned almost entirely with the tactile qualities of the paint and with sensitively considered color relationships. Only the skyline is identifiable. You will find that by painting an abstraction, relieved of any confining factual elements, painting will become an even greater personal activity. In effect, the process boils down to the sensation—and the experience—of applying the paint.

The light areas of the painting are white gouache stained sometimes with cadmium red and sometimes with cobalt blue. I kept the mixture stiff, using very little water, and dry-brushed it on, taking advantage of the splayed and split bristles of my aged brush. I dragged the colors lightly over the surface and cross-hatched them over one another so that the colors underneath show through. This process gives a veiled, dry effect with the pink changing to gray.

In the foreground, I used more distinct and vigorous brushstrokes to give energy to the scene. The harshness of the foreground and its crude color contrast with the delicacy of the background and makes the changes there seem even more subtle.

FARM DETAILS

My painting is essentially concerned with the landscape and how man-made farm buildings are absorbed into it. Many of the farms I paint are centuries old, built with material dug by hand from the actual site, and they have weathered and eroded along with the landscape. Moss and lichen cling to the rough surfaces of the walls and roofs, the paint peels from doors and windows, and the elements have bleached the wood to a silvery gray. It seems to me that these building surfaces repeat the surfaces of the landscape—smooth in parts, sometimes cracked, and sometimes broken into gritty, rough textures. The result is that I no longer think of a building as a separate object but as part of the landscape, sharing its particular characteristics at that one moment in time.

When I look at a farm building, I look for details of its architecture and construction—how timbers join together, how masonry is laid—and mentally try to rebuild the farm in my mind. I even like to finger the rough surfaces of the stone and timber, and as I do this, my mind wanders. Then I draw what I see and feel. The drawing itself completes the process of inquiry. Your drawn lines are more than mere pencil marks; they recreate the

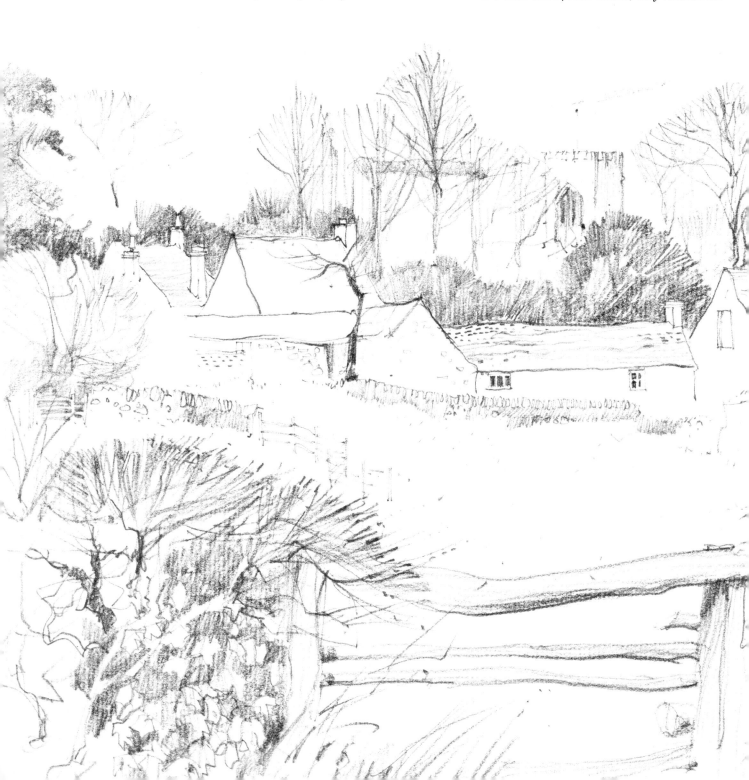

building and express its construction. To draw, place the pencil point firmly on the paper and move it decisively, then stop and look at the building, and draw again. The drawing should build up in a progression of such considered and planned movements.

You must also react to the building's shape, textures, and values. Ask youself: How light or dark is it? Is the main feature hard-edged and contrasty or does it blend softly into its surroundings? How hard or soft are its edges? You must think in terms of such abstract qualities when you paint because they provide the key to sensitive personal expression. Hard edges are assertive, soft edges melt together, and in between there are varying degrees of softness, some edges appearing and disappearing, enticing the eye to further explore the mysterious shapes they form. These abstract forms and shapes, sometimes hinted at and sometimes aggressively stated, are the essence of the subject matter on a farm. Therefore, in painting a farm, you must be careful not to define your subject in realistic terms alone. To paint a building as a building would destroy the magic!

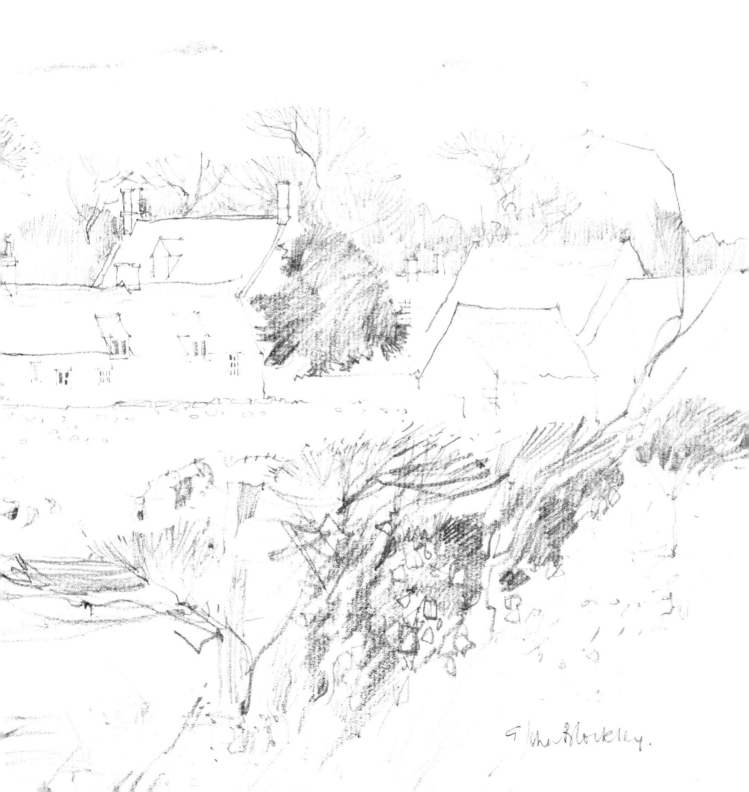

Treating architectural detail as the center of interest

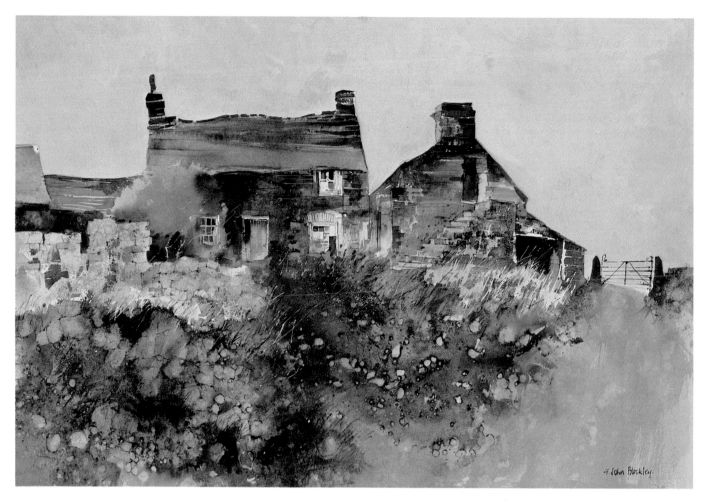

BLACK COTTAGE, ANGLESEY, *15" x 22" (380 x 560 mm)*

I was first attracted by the mass of this building and the interesting profile its roof made against the sky. Silhouetted in the bright, late afternoon sun, the cottage looked very black to me. In fact, I shall always think of it as the "black cottage," although it was not really that color. From a distance, I could see the main characteristics of the building: its solidity and the mass of its big chimney and the smaller chimneys.

SUGGESTED PROJECT

Characterize a building by emphasizing certain features and subordinating (or eliminating) others. First decide what feelings the building evokes in you, then figure out which details best express them, and finally, make a few thumbnail sketches of compositional arrangements (or close-ups of details) that best express your sentiments. Pay particular attention to value contrasts and edges, and look for areas where you can express interesting textures, details, or shapes.

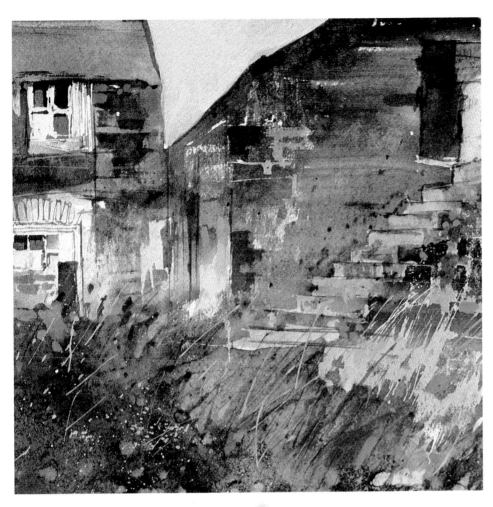

As I got closer, I became aware of architectural details—the arch of bricks set above the small-paned windows, the simple doorways, and the solidly built stairs that led to the barn loft. I made special note of these details, because they gave the building its individual character and were therefore to be emphasized and exploited in my painting. In painting a building, details like these are as important in expressing the character of the place as you perceive it as the features of someone's face are in expressing personality in a portrait.

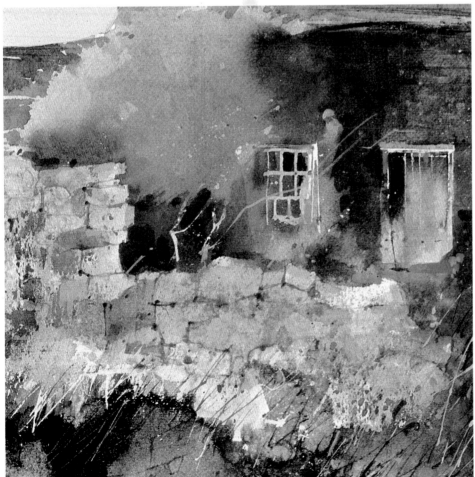

Because the scene was backlit, I painted the building and the ground with the same warm color to create unity within the shadow area. I used a flat brush to paint the cottage, sometimes working in short, abrupt strokes that touched and merged, all the while feeling for the solidity of each mass. I contrasted the disciplined treatment of the building against a freely painted foreground that took advantage of watercolor's soft, spreading qualities. To set off the decorative foreground and architecture, I painted a simple, flat sky and used the cool tones of the sky as a foil to the generally warm colors in the land. Finally, as a finishing detail, I added the small iron gate suspended between two large slabs of slate on the right—I liked the way it opened into space.

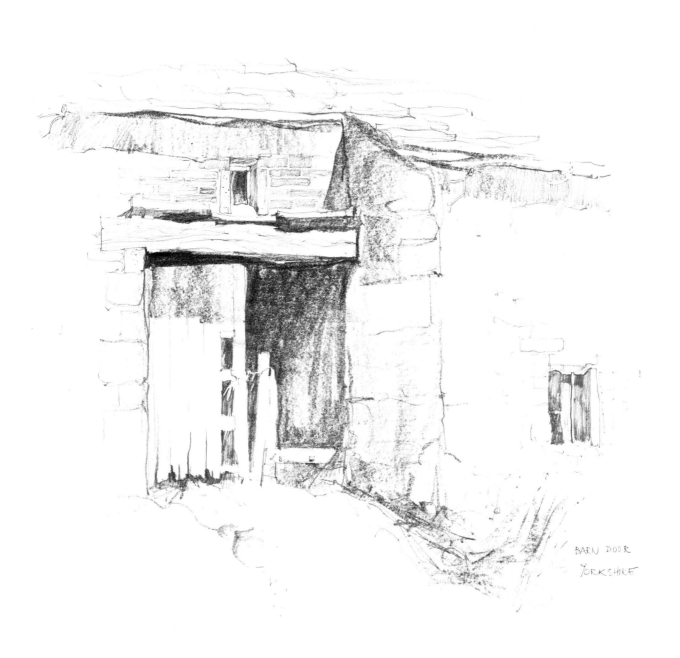

BARN DOOR
YORKSHIRE

This is a close-up of the abandoned barns in Yorkshire (page 117). There were many interesting details to focus on. The windows were set back in the thick walls and were flanked on each side by vertical slabs of stone. The lower window had a single protecting iron bar, and a massive beam supported the roof, which was of big, thick stone slabs. The corners of the building had large stone "quoins," in comparison with the smaller stones of the walls. They were placed in fascinating patterns—some vertical, some horizontal, some thin, and others square. But even though I was fascinated by these details, I still managed to concentrate attention on the door itself by keeping it light and by placing it against an even stronger dark.

I was attracted to the strong pattern of dark and light and to the cast shadow of the door latch, elongated by the slanted sun to make a pleasing design against the sunlit door. As soon as I started to draw, I became involved in the latch's individual properties. For instance, I could tell by the thickness of the rectangular loop that enclosed the latch that it was very old. Also, the dip in the top of the shadow on it revealed that the loop had been swollen at the bends when it was forged, and its shape was now slightly concave. These are the subtle characteristics that must be recorded when drawing a detail, or your drawings will lack interest.

Making ordinary objects interesting

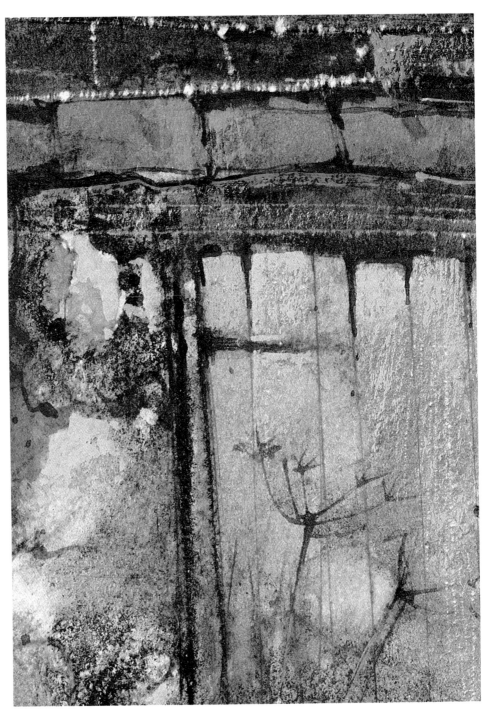

SHED DOOR, *8" x 7½" (205 x 190 mm)*

A detail such as a shed door may seem too humble to be worth painting. However, I love making small paintings of everyday objects like this door because they can be interpreted more freely and personally than can more obvious painting subjects.

SUGGESTED PROJECT
For interest and a fresh approach, it is a good idea to vary the scale of your subjects—as well as the size of your paper and shape of your format, switching sometimes from a horizontal to a vertical or even a square shape. Each variation will present a different challenge in composing your paintings. Also, even in larger paintings, try to reduce the amount of detailed drawing and rely as much as possible on suggestion.

I was particularly intrigued here by the play of textures—the small fragile plants against the blotched surfaces of the stone shed—and liked the echoing rectangle of the shingles, door frame, wooden door slats, and the stone wall and windowpanes beyond. After I laid down several washes of light color and created a few dark blots of waterproof ink, I let the paper dry and then added definition with a steel-nibbed pen dipped in burnt umber watercolor. I lightly dragged opaque tones of yellow ochre, burnt sienna, burnt umber, and white over the door with a dry brush, letting the vertical movement of the brushstrokes suggest the wood grain. Across the roofline, I added a wavy stroke of Paynes gray and gouache—a light-hearted touch to soften that powerful horizontal. When the paint dried, I scratched out uneven white streaks with a sharp razor blade.

Balancing an asymmetrical composition

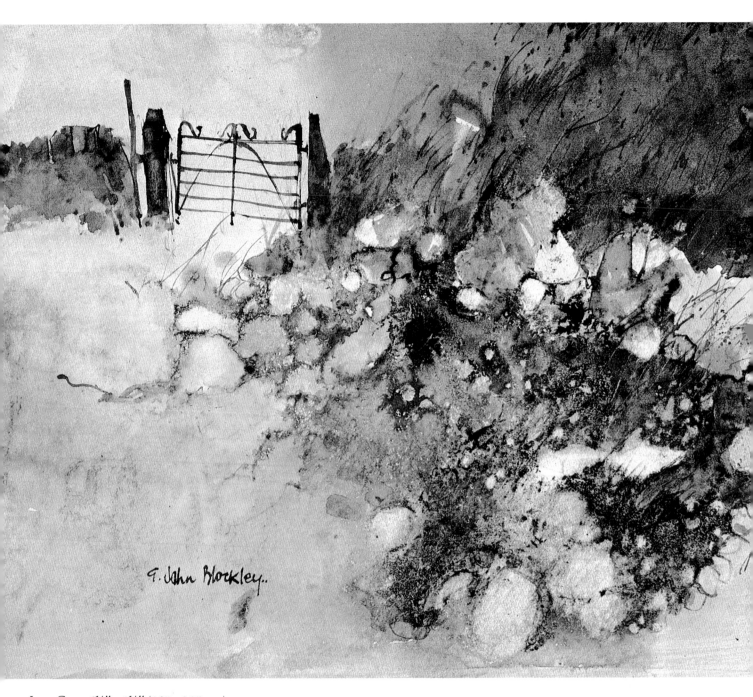

IRON GATE, *6½″ x 8½″ (165 x 215 mm)*

The gate hung between two stone gateposts and the ground fell away steeply on one side. To create a buildup of interest toward the gate, I placed it high on the paper and divided the large foreground into a quiet and an active area so they would balance each other and not take attention from the center of interest, the small gate at top. In the patterned foreground area on the right, I hinted at grass, lichen, and the coarse texture of the stone-reinforced bank. In contrast, I kept the area on the left smooth and bare, almost marbled in appearance—and I chose a hard, smooth-surfaced paper to help achieve that texture. I drew the gate itself in a few simple lines with a fine brush and watercolor—I sometimes substitute pen and ink—adding interesting details, such as the way the metal curled decoratively on top and the positions of the hinges and the latch, to make the painting convincing.

SUGGESTED PROJECT
Paint a simple scene with a single area of interest and balance it against the rest of the painting. To keep the larger areas from being dull, color or texture them in a subtle, yet appealing way.

Interesting hand-forged Hinges

Roof over old Pigs

Hay

Timber bleached

Unusual big panelled doors

Cows

The old timber barn at "Offas View" Forden Montgomery.

As a boy, I spent my vacation on a very small farm in central Wales owned by my grandfather. Revisiting it recently, I made several quick sketches for future reference. The timber barn, once painted black, had weathered in parts to an almost silver gray, and I knew its overlapping timber construction and interesting windows and doors would make a good painting. I also recorded several of its details—rusty hinges and door latches—that were also interesting.

This is a very rapid note in felt-tip pen and pencil, just a personal note to myself to register the essentials of the scene and jot down my impression of the old stone cottage. It was on high ground, sloping steeply down to where I stood, so that when I paint it, I will place the cottage high on the paper with the ground sloping toward me. This sloping ground will occupy perhaps two thirds of the paper, but there was no need to include it in my sketch since it was just rough ground, and that I could remember. Instead, I concentrated on sketching the cottage. I like looking up at a subject—it looks even more important and dominant that way. The tall chimney seems to emphasize this importance and I like the roof thrusting itself upward.

My note on the sketch says that the roof is silver gray against a pewter sky. This is a pleasing color relationship that I shall probably use, but I suspect that I instinctively exaggerated the dark background to emphasize the chimney and the tilted roof. I also think that it gave me an opportunity to paint a counterchange design—the light roof against a dark sky and a dark bush against a light sky.

The scribbled sketch below suggests that I might enlarge the bush, but looking at it now, after an interval of time, I think my first-time sketch gives a more satisfactory balance of light and dark masses.

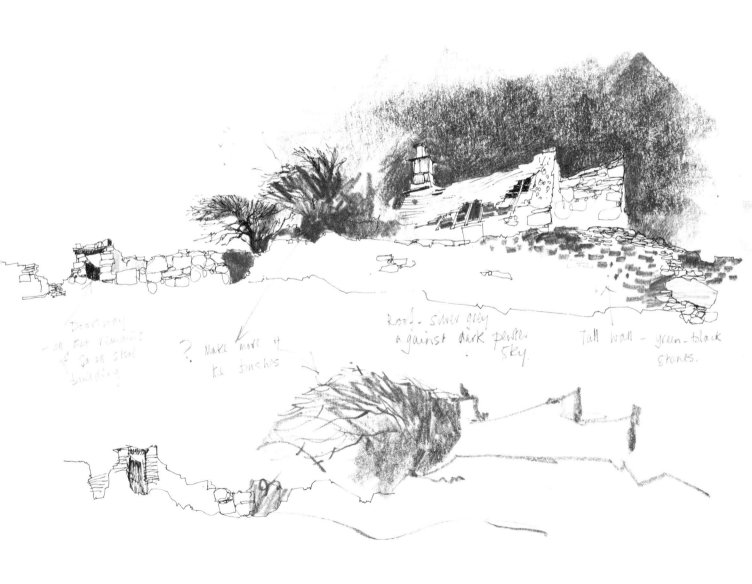

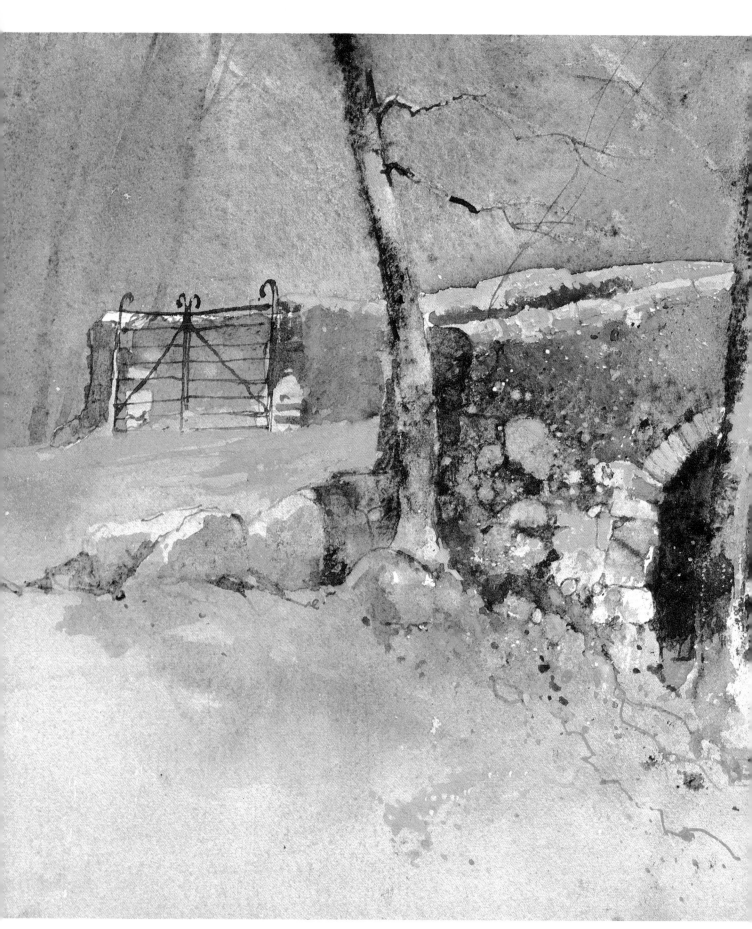

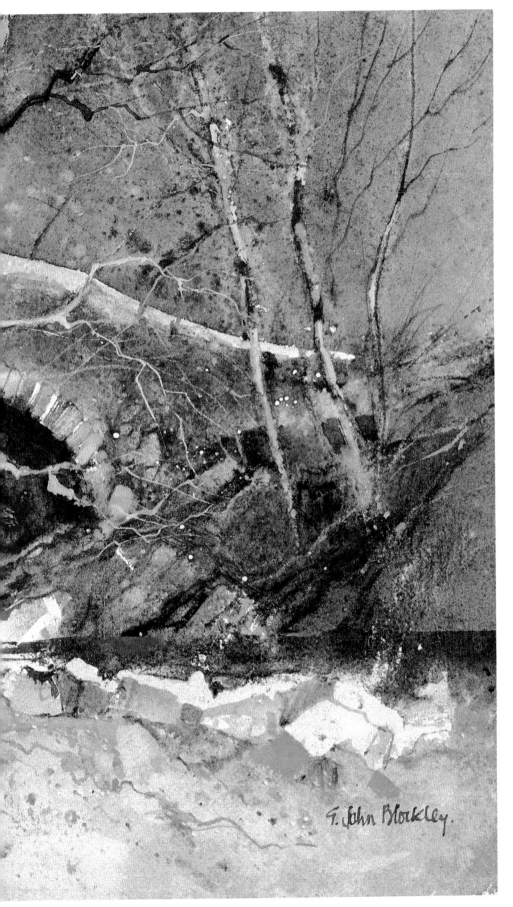

F. John Blockley.

FARM BRIDGE, *8″ x 12″ (203 x 305 mm)*

I wanted to capture this hazy atmosphere of early morning and show how the rough textures of the bridge complemented that softness. To do this, I limited the number of hard edges, confining them mainly to the top of the bridge, the arch, and the tops of a few boulders. (I masked them out before I started.) I was careful not to get carried away with the texture of the bridge stonework, but used it discreetly, mainly in the nearer part of the bridge. I had previously tried a vertical format, with the bridge high in the painting, but decided that a horizontal format was better suited to the quiet, softer treatment I wanted. The foreground trees cutting across the bridge provide sufficient vertical interest.

I painted the background and foreground with wet-into-wet washes of diluted cadmium red and Paynes gray, and the bridge with hints of raw sienna that I mixed with the Paynes gray to make a gray green. After the washes were dry, I strengthened the darks and added definition by drawing with the brush. Then I rubbed the masking fluid away and tinted the stones and branches. I strengthened the bridge by painting its upper edge and the arch below with touches of gouache.

SUGGESTED PROJECT

Try to evoke a misty atmosphere by interplaying hard edges against soft ones. Reserve the hardest edges for the nearest objects, and keep the brightest and darkest tones for the foreground. Also play warm tones against cool ones to express the light, keeping the most distant hues light and soft.

I discovered this sturdy wagon in a barn near my house. Both these wagons were all handmade, and I made the sketch simply because I was interested in the construction of the wheels and their curved spokes—the drawing shows one of the near wheels and one of the smaller front ones. The front wheels are supported on a heavy timber axle that pivots to help the wagon turn.

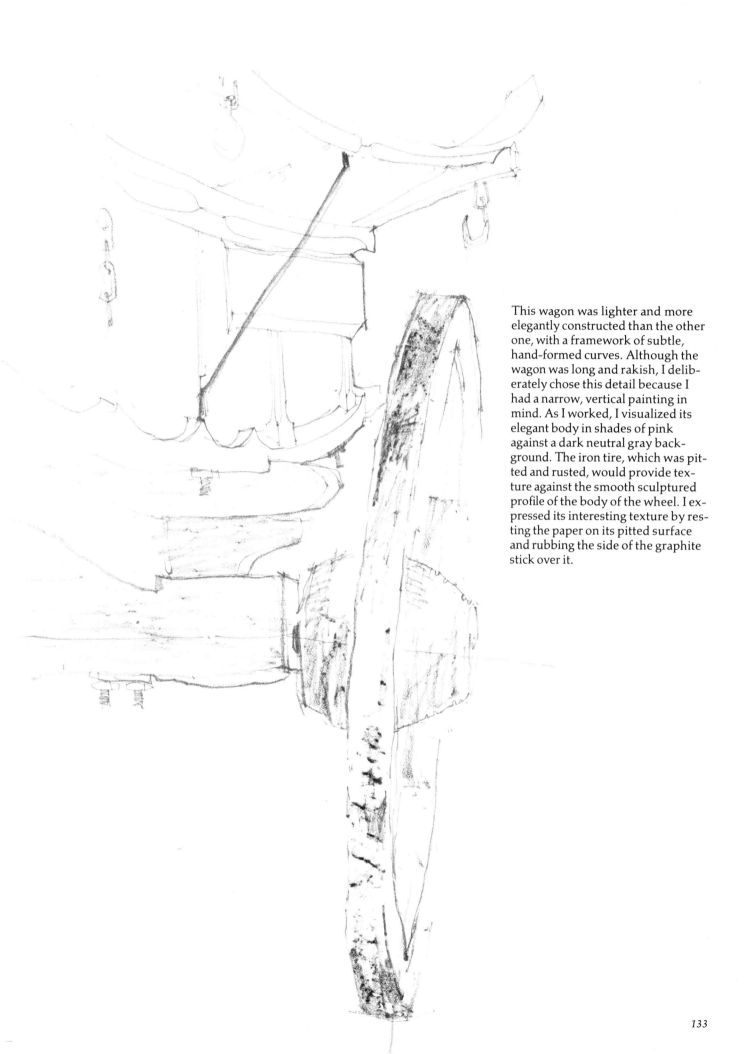

This wagon was lighter and more elegantly constructed than the other one, with a framework of subtle, hand-formed curves. Although the wagon was long and rakish, I deliberately chose this detail because I had a narrow, vertical painting in mind. As I worked, I visualized its elegant body in shades of pink against a dark neutral gray background. The iron tire, which was pitted and rusted, would provide texture against the smooth sculptured profile of the body of the wheel. I expressed its interesting texture by resting the paper on its pitted surface and rubbing the side of the graphite stick over it.

Masking negative shapes

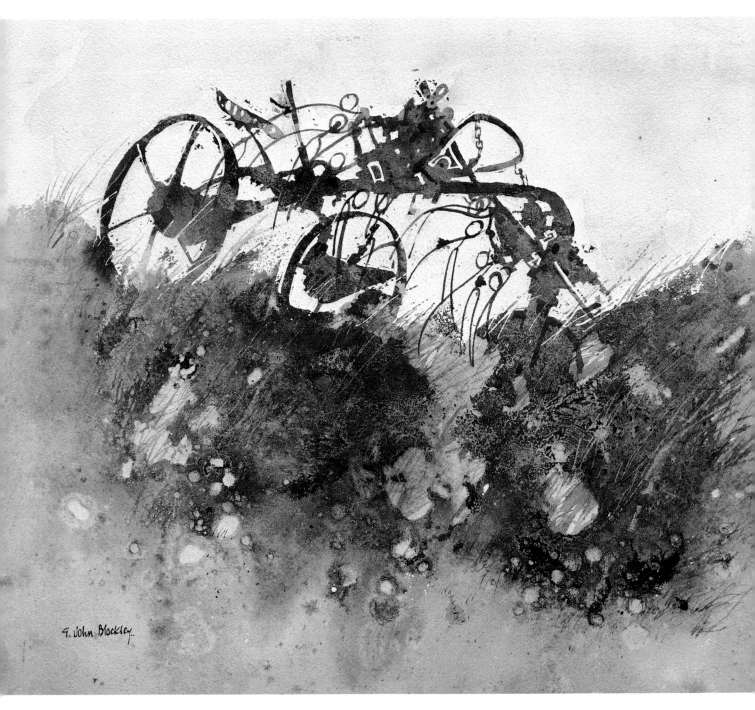

ABANDONED HAY RAKE, *12" x 14" (305 x 355 mm)*

I was immediately attracted to this old hay-raking machine. First, it aroused the obvious sentimental values associated with old machinery. Then, its construction was interesting, almost unreal, like a cartoonist's contraption. I was also delighted by the way the ellipses of the wheels were echoed by the small loops in the prongs of the rake. But, most of all, the machine reminded me of a pattern in relief—like a woodcut—with the surrounding negative space chiseled away to leave the image standing out against the stark sky. I therefore painted it from a low angle to emphasize that feeling and purposely kept the foreground soft by painting it wet-into-wet to serve as a foil to the hard edges of the machinery. I also blotted out soft spots in the foreground that repeated the movements and shapes of the sky patches and metal rings of the hay rake. I repeated the flowing motions of the prongs in the tall, waving grass to tie the painting together and emphasize the rhythmic feeling the rake evoked.

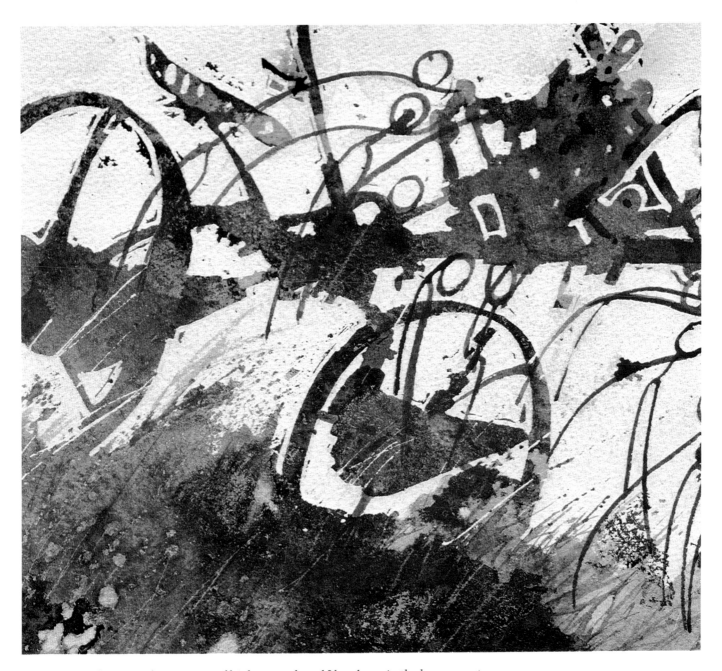

The rusty machine stood on an area of high ground, and I lay down in the long grass to draw it, thereby emphasizing its interesting, strong silhouette against the clear sky. As I studied the machine, I saw it as a pattern in relief, with the empty spaces chiseled away and the lines of the image left solid. So when I came to paint it, I decided to use a process that would give me that sharp-edged quality: I first masked out the surrounding negative spaces (the sky and background) with masking fluid, leaving white paper for the rake. Then I quickly painted the complicated lines of the machine, working the paint toward the outer edges of the masked areas by brushing many short strokes across the width of the machine (instead of the normal way of painting each line smoothly, with a long stroke). These uneven strokes, applied at right angles to the edge of the masking fluid, resulted in an edge that is subtly different in quality from one painted continuously. I also deliberately left bits of paper showing through when I masked the sky so that when I applied the paint to the machine, slivers of color caught in the sky area, evoking even more strongly the look of a hand-carved woodblock or linoleum print.

SUGGESTED PROJECT
Paint a simple object—a kitchen chair, for example—and mask out the negative shapes in an interesting way. Then apply the paint as I have done here to see if you like the effect.

If you prefer to use another approach to a simple object, try a painting where you emphasize some distinctive quality about an object that appeals to you. Try to capture this in paint. Here both the low angle of the artist and the unusual technique of painting the hay rake help evoke a personal response to the object.

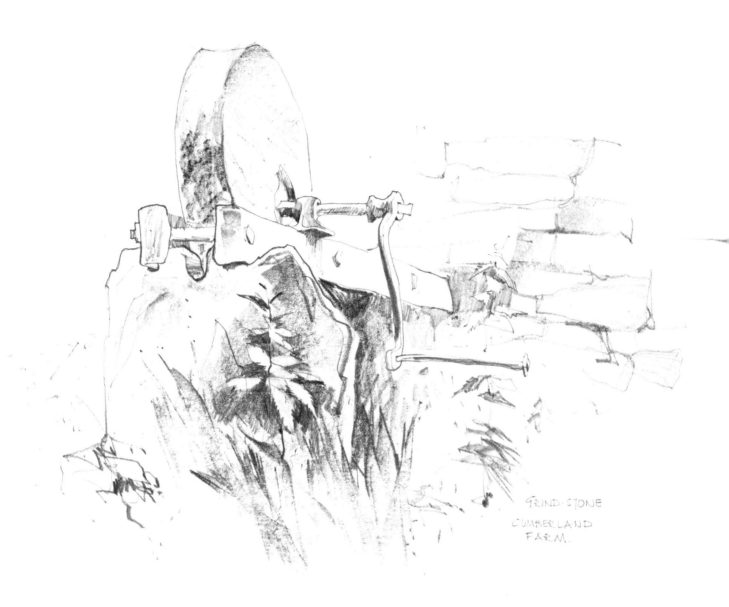

GRIND·STONE
CUMBERLAND
FARM.

I thought it would be more interesting to show this grindstone from the underside
rather than a more conventional vantage point, so I crouched down in the grass to
draw it. As I drew, I carefully observed the construction of the various parts. I was
particularly intrigued by the farmer's ingenious improvisations, supporting the grind-
stone on two steel bars pushed into a stone wall, resting in the front on a stone slab. I
used a sharp pencil to suggest the taut curves of the forged handle and a stick of
graphite for the heavier tones and lines. To magnify the effect of the strong perspec-
tive, I increased the pencil pressure where the object was nearer.

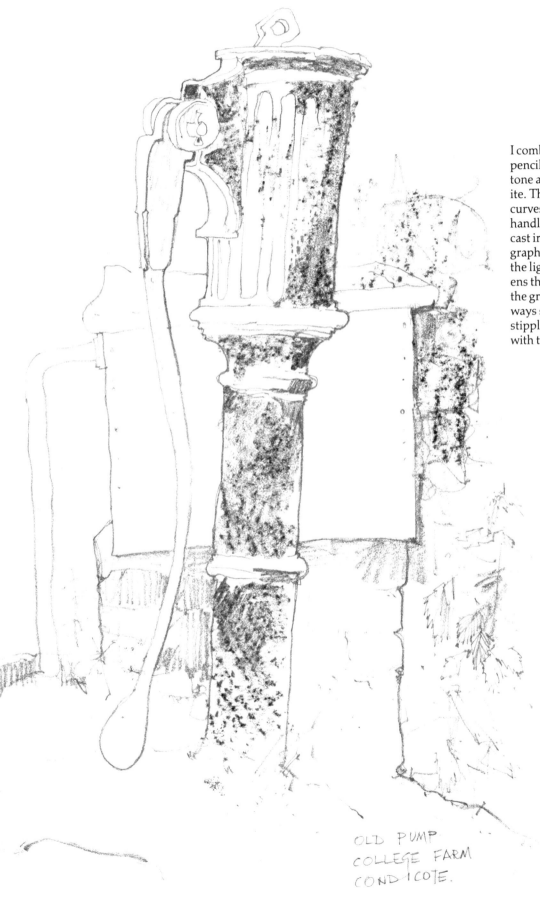

OLD PUMP
COLLEGE FARM
CONDICOTE.

I combined the lines from a sharp pencil with the strength of line and tone achieved with a stick of graphite. The thin pencil line describes the curves and shape of the forged handle and the ornamentation of the cast iron pump body. The coarser graphite tone on the pump is a foil to the lighter pencil work and strengthens the drawing. I dragged the side of the graphite stick with quick sideways strokes on the paper and stippled the paper by stabbing it with the end of the graphite stick.

Capturing the effect of daylight on interior walls

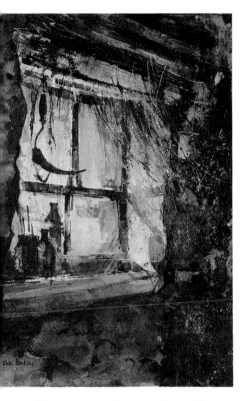

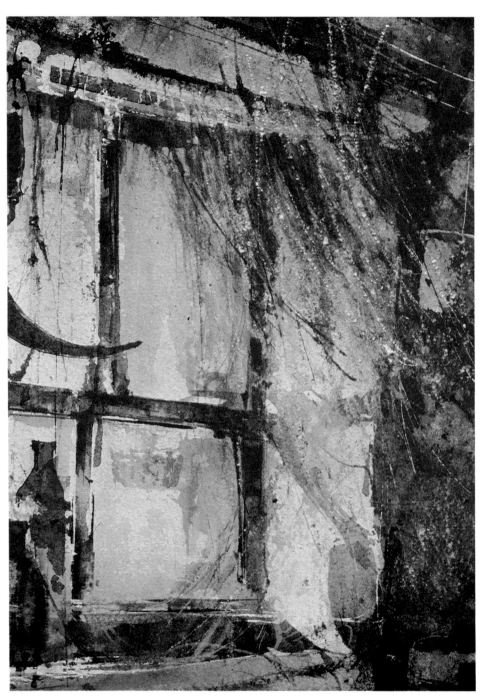

WINDOW WITH SICKLE, 8" x 12" (205 x 305 mm)

Here are two interpretations of windows viewed from the inside of stone barns. In this painting, my subject is the daylight that penetrates the cobwebbed glass to create patches of light on the walls surrounding the window. To show this, I have relied on contrasting values, painting the barn wall dark and silhouetting the sickle and bottles against the light windowpane. In painting an interior of this sort, the values of objects must be judged with great accuracy—and painted as they actually are, not as you think they should be. For example, even a white interior wall will appear dark when it surrounds an exterior light. You must compare the tone of the wall to the light that comes in from the window, not assume it is actually white simply because white paint was originally used to paint it.

I looked for contrasts in tone, texture, and edges to express the mood of this interior. I was particularly intrigued by the interplay of the warm, dark shapes against the cool, white textures of the windowpane and by the soft, tangled cobwebs—some of which were scratched out of the dry washes later with the sharp point of a pen—that floated about like the hair of a wild man. I also used contrasting treatments—warm, soft, dark transparent washes for the interior and stiffer, textured, cool, opaque brushstrokes for the exterior light.

SUGGESTED PROJECT
Paint a window with objects on the windowsill or hanging in front of it, and try to make it appealing through shape and value contrasts. You may even wish to experiment by making it an abstraction.

Using natural light to reveal textures

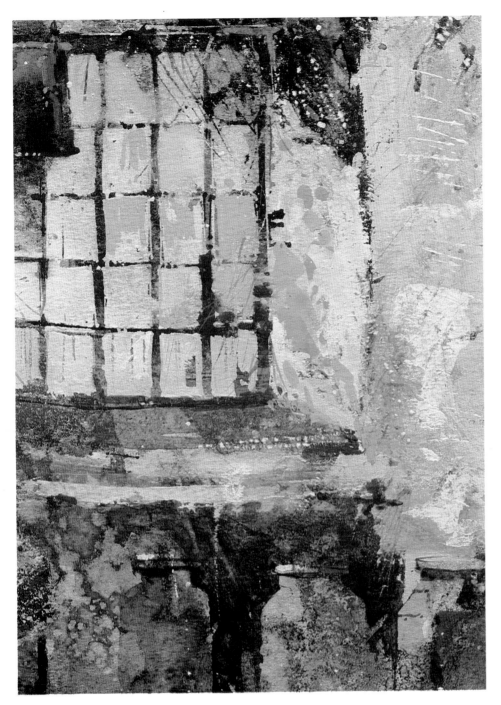

BARN WINDOW, INTERIOR, *9″ x 12″*
(230 x 305 mm)

This painting of a barn window set in a white interior wall seems to contradict the previously stated theory—that the light coming in from a window is lighter and brighter than are the white walls of an interior. But rules must be considered in context, and in this case, the subject of my painting is not the bright exterior light but the interesting surface qualities of the rough, white walls. These walls were crusted with many layers of white paint that over the years had been applied roughly and with stiff brushes so that the brushmarks showed in the thick layers of paint. Had I painted these walls dark, I could never have focused interest on them and their rough texture would have been lost.

I washed transparent varied colors over the wall area, blotting up occasional shapes and textures before the washes dried. Then I scumbled over the wash with light tints of opaque colors to suggest a roughly whitewashed interior. As you can see, there is no contrast between the light windowpanes and the right-hand wall. I still relied on contrasts of light and dark, however, in the dark wood that encased the windowpanes and in the dark shadows surrounding and emphasizing the mottled shapes of the milk cans. I painted the opaque textures with a stiff oil painter's bristle brush in crisscrossing strokes to give it the impression of being roughly painted, exposing bits of the dark underpaint.

SUGGESTED PROJECT
Experiment by scumbling opaque paint over a transparent dark wash, using this process for other subjects. For example, try painting a landscape with dark colors, then scumble pale tints of gouache over it. The idea is to let the pale dark underpainting show beneath the opaque brushstrokes.

These cooking ranges are in a row of farm cottages near my studio. Each cottage has a different design, some having one oven and some with two. I would like to paint them someday as a series, all the same size.

shelf edged with copper strip (nailed on)

These cast iron cooking ranges are in neighbouring cottages. — now abandoned. I sat on the stone floor to sketch them — quickly. The walls were black with damp. Each cottage had one living room 11 feet square with ceilings 6½ feet high. There were hooks in the ceiling for hanging bacon — must have been tricky to walk about. Each cottage had another room, nearly 6 feet square, with a sink for washing. — and two bedrooms above.

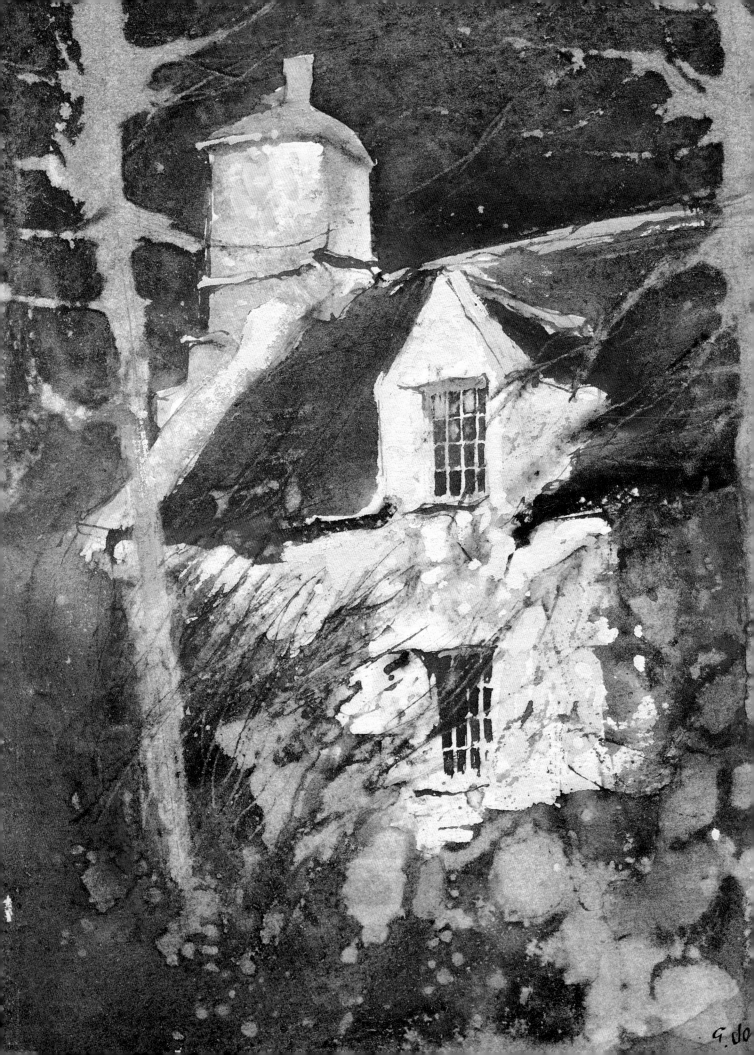

Focus and out-of-focus treatment

CottAGE Window, *8" x 7" (203 x 178 mm)*

In this painting, I used an out-of-focus treatment, letting blurred foreground forms surround and concentrate attention on a more distant, in-focus form. The result is a reversal of the actual truth—the more distant features being positive and hard-edged, and the nearer features negative and soft-edged. In fact, I often call this "an untruth to emphasize a truth."

My purpose here was to describe a window in dappled light emerging from a background of subdued, mysterious forms. I therefore made this window the lightest area of the painting and have placed my greatest contrasts and hardest edges there. All other areas are relatively subdued. For example, the chimney is darker than the window and the trees and foreground less contrasty. I used a negative treatment for the trees, making them soft-edged and almost ghostlike by blotting them out of the dark background wash. I did the same in the foreground, creating undefined, soft-edged shapes. But I handled the windowframe in the opposite manner—not as a reductive area, but as a positive one, by adding dabs of opaque white gouache to it.

SUGGESTED PROJECT
Try this focus and out-of-focus treatment on one of your own landscapes. The result should be somewhat like placing a soft-focus filter on a camera.

INDEX

Edited by Bonnie Silverstein and Lydia Chen
Designed by Jay Anning
Graphic production by Hector Campbell
Set in 11-point Palatino italic